Cecilia Jannella

SIMONE MARTINI

SCALA/RIVERSIDE

CONTENTS

© Copyright 1989 by SCALA, Istituto Fotografico
Editoriale S.p.A., Antella (Firenze)
Editing: Karin Stephan
Layout: Ilaria Casalino
Translation: Lisa Pelletti
Photographs: SCALA (M. Falsini and M. Sarri) except
no. 46 (Fitzwilliam Museum, Cambridge), no. 47
(Wallraf-Richartz Museum, Cologne), nos. 52 and 53
(Art Resource, New York), nos. 72 et 73 (Giraudon,
Paris), nos. 76 et 77 (Musée Royal des Beaux Arts,
Antwerp), no. 78 (Gemäldegalerie, Berlin-Dahlem) and
no. 79 (Walker Art Gallery, Liverpool)
Produced by SCALA
Printed in Italy by Lito Terrazzi, Cascine del Riccio
Florence 1989

1. *Miracle of the Resurrected Child*
Detail of the presumed self-portrait
Assisi, San Francesco

1

The Life of Simone Martini

If one were to reconstruct the life of Simone Martini using only documented facts one would have a very short account, with a great many gaps. So, in this text, we will also be making use of many of the elements that have been handed down by traditional accounts, even though most of them find no direct confirmation in the documents of the time. But by comparing and relating them to the nature and the style of Simone's works, we shall be able to reconstruct the great artist's life story.

Let us begin this short historical and chronological account from the date of Simone's death, which we know for certain. An obituary notice in the monastery of San Domenico in Siena, dated 4 August 1344, reads as follows: "Magister Simon (pictor) mortuus est in Curia; cuius exequias fecimus in Conventu die iiij mensis augusti 1344" (Master Simon, painter, died in the Curia; his funeral was held in the convent on the 4th day of the month of August 1344). If we are to believe Vasari, who tells us that on Simone's tomb there was an epitaph stating that he had died at the age of sixty, then the artist must have been born around 1284.

What did Simone look like? He was probably not a very handsome man, at least according to Petrarch, who was a close friend of his. Some scholars claim that the Christ before Pilate on the back of Duccio's *Maestà* in the Palazzo Pubblico in Siena is a portrait of Simone; others believe that he is the knight with the blue hat who is witnessing, half amused, half in disbelief, the *Miracle of the Resurrected Child* in the Chapel of San Martino in the Lower Church of San Francesco in Assisi.

Unfortunately, we know nothing of the first thirty years of his life; but, despite this rather discouraging lack of concrete information, a good number of fairly plausible suggestions have been made. He may have been born in Siena, in the neighbourhood of Sant'Egidio; or perhaps, according to the theory of Enzo Carli, he was born in the countryside around Siena, near San Gimignano, the son of a Master Martino specialized in the preparation of the *arriccio* (or first coat) applied to wall surfaces to be frescoed. Simone most probably learnt the trade in the workshop of Duccio di Buoninsegna, but he only became well-known as an artist when he painted the *Maestà* in

the Sala del Mappamondo in the Palazzo Pubblico in Siena: the inscription around the frame of this fresco gives the date, "mille trecento quindici" (1315), and the author, "a man di Symone" (by the hand of Simone). If we consider that the Commune of Siena chose Simone as the artist to paint such an important fresco, we can assume that he must already have had quite a good reputation before he was commissioned the *Maestà*. Working for the Commune on the decoration of the Palazzo Pubblico, the heart of the city both literally and symbolically, was an experience shared by all those who are today considered the greatest Sienese painters of the late 13th century and the first half of the 14th: Duccio, Simone and Ambrogio Lorenzetti. From the documents recording this commission we also learn something about Simone as an artist: he was very meticulous and took great care in his realistic landscape views. As we can see in the *Blessed Agostino Novello Altarpiece*, Simone was very accurate in his depictions of town scenes and details: arcades, mullioned windows and rooftops (and also the interior of a house) offer us a very realistic picture of 14th-century Siena. But his love of realism made him go even further: when the government commissioned a series of paintings showing the castles that the city's troops had conquered in neighbouring areas, "Maestro Simone dipegnitore" actually went in person to look at the places, "chon un chavallo et uno fante a la terra d'Arcidosso et di Chastel del Piano" (with a horse and a servant he travelled to Arcidosso and Castel del Piano). Simone painted the capture of Arcidosso and Castel del Piano in the Sala del Mappamondo in December 1331: most scholars agree that this fresco has been destroyed, but some believe that it is the one discovered a short while ago below the *Guidoriccio*.

According to Ferdinando Bologna's plausible reconstruction of Martini's life and work, it appears that he travelled frequently from Siena to Assisi and viceversa. It seems that between 1312 and 1315 he did the drawings for the stained-glass windows in the Chapel of San Martino in the Lower Church in Assisi, for these windows certainly look earlier and more archaic from a stylistic point of view than the frescoes in the same chapel (finished by 1317). In 1315 he painted the *Maestà* in the Palazzo Pubblico in Siena and probably also did some more work in Assisi, on the frescoes in the Chapel of San Martino. Also in 1315, as a result of the canonization of Louis of Toulouse, Simone probably received the commission for the *Naples Altarpiece*, a signed painting which is traditionally supposed to have been painted in Naples, although there is no evidence to support this theory. There is an interesting document, an order of payment dated 23 July 1317, in which Robert of Anjou instructs that "Simone Martini milite" be paid: Simone is not referred to as a painter, but as a "miles," a term used in the Middle Ages to mean a knight. According to Bologna's reconstruction, Simone must have been knighted for having paid tribute to King Robert, his family and the French royal lineage both in the frescoes in Assisi and in the *Naples Altarpiece*. It was fairly common procedure in the late Middle Ages for a sovereign to knight an artist for such merits.

We have already spoken of Simone's realism, but it is interesting to hear what Vasari had to say about it: "He loved to portray from nature and in this he was considered the best master of his day." In mediaeval painting the first individual portraits are to be found in the work of Simone, who appears to have noticed before his contemporaries the uniqueness of the features of his single subjects. Take, for example, the sharp profile of King Robert in the *Naples Altarpiece*, or the obsequious expression of Cardinal Gentile Partino da Montefiore above the arch over the entrance door to the Chapel of San Martino: both of these are indicative of the extraordinary talent that Simone showed in his portraits. What a shame that the portrait of the beautiful Laura that Simone painted for Petrarch has not survived: it must indeed have been quite splendid, for the great poet wrote two sonnets inspired by its beauty.

A large and quite varied group of panel paintings is normally dated around the late 1310s and the early 1320s. By examining them we shall be able to follow Simone's artistic development: the pre-Giottesque style of Assisi and the reminiscences of Duccio's art are filtered through a more openly Gothic style expressed in innovative volume constructions, with images set in bright and spacious areas, with sinuous and sharp lines. Our documentation on this group of paintings is so scarce that we know for certain the dates of only two of them: the polyptych for the church of Santa Caterina in Pisa (1319) and the one in the Museum at Orvieto (1320). As far as the others are concerned, especially the numerous polyptychs produced in the Orvieto workshop, most recent scholars tend to date them at the early 1320s, but entirely on stylistic grounds, for there is no documentary evidence at all. In any case, an

2. Madonna and Child (no. 583)
88 x 57 cm
Siena, Pinacoteca

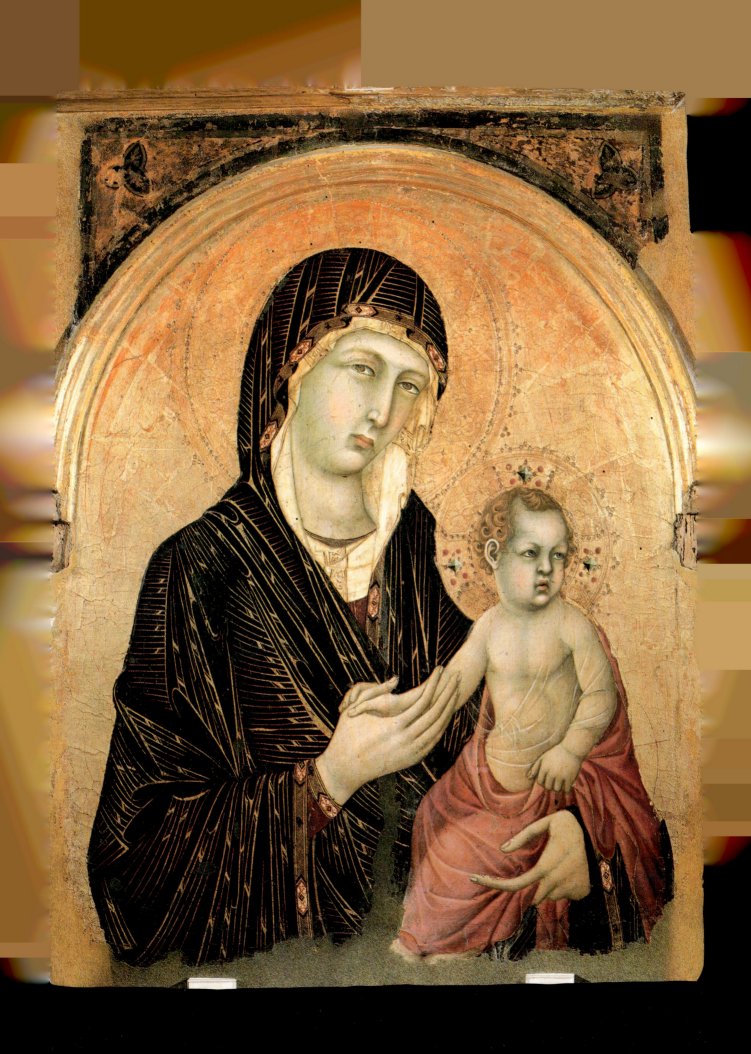

accurate study of Simone's production in Orvieto is extremely difficult, for all the paintings attributed to him show quite considerable interventions by assistants.

All through the 1320s the Biccherna registers (the Commune of Siena's accounting ledgers) record payments to Martini, evidence that he must have worked a great deal in Siena before leaving for Avignon. These documents refer to a variety of paintings, many of which have not been identified or have not survived. In 1321 Simone 5 was paid to restore his own *Maestà*, which had been damaged already by rainwater infiltrations in the wall, and for the work he had done on a painted Crucifix (which was eventually completed by his pupil, Cino di Mino Ughi). In 1322 and 1323 "Maestro Simone Martini depintore" was paid for a variety of works, not specified, painted for the Palazzo Pubblico. In 1324 he married Giovanna, the daughter of Memmo di Filippuccio and the sister of Lippo Memmi. Simone may have been a rich man, for his activity as a painter certainly provided him with a substantial revenue. Shortly before his marriage, in January or February 1324, he bought a house from his future father-in-law and presented to his wife-to-be a "propter nuptias," a wedding gift, of two hundred and twenty gold florins: almost thirty times as much as he was paid a few years later for the paintings of the castles of Arcidosso and Castel del Piano! Perhaps with an excess of sentimentalism, this gift has been interpreted as a sign of gratitude: after all, Simone was already past forty and not very handsome, so he was grateful to the young girl for accepting to marry him. Whatever the truth may be, the gift is undoubtedly evidence of his generosity, a trait that comes across quite clearly in his last will and testament as well. Simone married into Lippo's family, then, and this further strengthened a bond of friendship and artistic collaboration that lasted throughout their 69 careers, reaching its highpoint in the *Annunciation* in the Uffizi where it is actually quite difficult to distinguish Simone's work from Lippo's.

Also presumably dating from the 1320s are the 62 Altarpiece of the *Blessed Agostino Novello* and 63 the small tempera portrayal of *St Ladislaus, King of Hungary*. Not all scholars agree on this dating, but Max Seidel's perceptive theories about the altarpiece formerly in the church of Sant'Agostino and now in the Siena Pinacoteca and those by Bologna concerning the painting in the Museum of Santa Maria della Consolazione (formerly in the church of the same name) in Altomonte, have helped us reconstruct the history of the two works. In 1326 Simone must have painted a

panel for the Palazzo del Capitano del Popolo: we know this must have been a very important painting, both because of the huge sum of money he was paid for it and because Ghiberti, in his 15th-century *Commentaries*, described it as "molto buona," and we know that Ghiberti was never a great admirer of Simone's, since he thought Ambrogio Lorenzetti was a better painter. The following year Simone painted two banners which have not survived; they were presented by the Commune of Siena to Duke Charles of Calabria, the son of Robert of Anjou. In 1329/30 he painted "two little angels on the altar of the Nine" in the Palazzo Pubblico in Siena and a portrayal of the rebel Marco Regoli (who was hanged by his feet, a form of execution reserved for traitors and forgers) in the Sala del Concistoro; neither of these frescoes has survived. Also in 1330 Simone painted in the Palazzo Pubblico one of his most celebrated works, the fresco of *Guidoriccio da* 64 *Fogliano*, a commemoration of the conquest of the castle of Montemassi in 1328 (the date, "MCCCXXVIII," under the fresco refers to the conquest and not to the fresco). The recent discovery of another fresco below this one depicting a similar scene, has raised some doubts as to the attribution. The history behind the Guidoriccio, its meaning and iconography, have been the object of a very animated debate amongst the most authoritative art historians.

The date 1333 appears on the frame of the *An-nunciation* painted for Siena Cathedral: this is the 69 last painting we know of that Simone worked on before moving to France. The primary consequence of the Papal See being transferred to Avignon in the early 14th century was that it transformed that small Provençal city into an artistic centre of European renown: paintings, artists and entire workshops, incentivated primarily by the Italian cardinals, were transferred to Avignon, and Simone, too, moved there in 1336. In what became the busiest art centre of the century, the style of the northern artists soon blended with the aristocratic elegance of Italian painting, especially the art of Simone, laying the foundations for the International Gothic style, an art of exquisite courtly refinement, of which Martini is generally considered a forerunner.

Although a member of a very stratified society (common citizens, imperial power and feudal hierarchy, the Pope and the Papal State), Simone was always associated with the highest social levels. His career evolved from one important commission to the next, always at the service of the highest powers. While in Siena he worked for the Government of the Nine, decorating the palace

3. Madonna, detail
San Gimignano, Oratory of San Lorenzo in Ponte

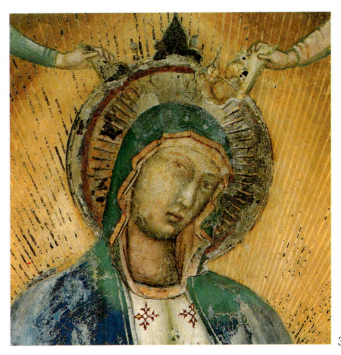

3

where they held their meetings; then he worked in the Basilica of San Francesco in Assisi, the most important institution of the Franciscan Order, but one which was temporal enough to be influenced by the current political situation. Then he gained the favour of the House of Anjou working at the Court of King Robert; and lastly he moved to Avignon to work for the most powerful members of the Church. From local painter to artist of European renown: his art went from secular subjects commissioned by the city's lay government, to holy subjects painted for Church patrons and even for royalty. But he always remained faithful to his style, an elegant, realistic and cultured art. His growing reputation as an artist must also have contributed to the general esteem he was held in, and we find his name appearing in documents in roles that required public trust: in 1326 he was a witness in a land rental contract, in 1340 he was given power of attorney in a legal dispute, and just before his death he was reimbursed the sums that he had advanced in order to obtain four Papal privileges for a Sienese hospital. These are all incidents that have nothing to do with his career as a painter, but they help us reconstruct his life history and his temperament.

The contrasting opinion of scholars on Simone's later works is the result of the lack of information available. Apart from the fragments of 72, 73 frescoes in Notre-Dame-des-Doms in Avignon, all that has survived from this period is the fron- 74 tispiece of Petrarch's copy of Virgil (now in the 79 Biblioteca Ambrosiana in Milan), the *Holy Family* in the Walker Art Gallery in Liverpool, dated

1342 and the polyptych of *Stories from the Pas-* 75-78 *sion* now belonging to the museums of Antwerp, Paris and Berlin.

Simone Martini died in Avignon in the summer of 1344. As Vasari tells us "he was overcome by a very serious infirmity. . . and not being able to withstand the gravity of the illness, he passed away." Clearly Simone was already ill and must have been aware that the end was near, for on 30 June he had already drawn up a will. The true nature of Simone, an extremely generous man, deeply attached to his family, comes across from this document, written and witnessed by the Florentine notary Ser Geppo di Ser Bonaiuto Galgani. All his worldly possessions (two houses, country properties with vineyards and a considerable sum of money) were divided between his wife, two nieces, Francesca and Giovanna, and his brother Donato's children. Since he had had no children of his own, Simone left almost all his wealth to his nieces and nephews. And his family loved him as much as he loved them, especially his wife Giovanna who returned to Siena from Avignon in 1347 (perhaps she was escaping the Black Death) all dressed in black, still in full mourning for her beloved Simone.

7

Simone Martini and Tuscany: Early Works

When Simone painted the *Maestà* in the Palazzo Pubblico his personal artistic style was fully developed, able to express original ideas and innovative compositions. This is consistent with what we know about him: he painted it in 1315, when he was about thirty years old. But we don't really know what he painted before then. He was probably working in Siena at the very beginning of the 14th century, learning the trade in Duccio's workshop, as some paintings recently attributed to his very early period would appear to suggest.

The *Madonna and Child*, no. 583 in the Siena Pinacoteca, after a variety of attributions, thanks to the research done by Giulietta Chelazzi Dini, is now accepted as the earliest known painting by Simone. It was the central panel of a polypytch (on either side there are holes to fasten the side panels to it) and the attribution is based on stylistic considerations: on the one hand, close ties to Duccio's painting; on the other, typical features of Simone's art. The Madonna is looking at the spectator: her erect position, the cloak enveloping her body, her sweet but sad eyes, are all elements typical of Duccio's art. But alongside these we find some totally new features: the sculptural quality of the veil around the Virgin's face and the play of light and shadow (notice how similar she is to Mary Magdalene in the *Maestà*); the restless movements of the Child, who turns his head towards the Saint to his left (the figure originally depicted on the side panel) and holds onto his mother's hand; his round body, his mouth, his curly hair and the perfect shape of his ear are all given exact volumes and concrete forms (similar typologies are to be found also in the Child between Saints Stephen and Ladislaus of Hungary in the Basilica in Assisi).

It is interesting here to draw a parallel with another early work, discovered by Carli who believes that Simone painted it between 1311 and 1314. It is the *Madonna* in the Oratory of San Lorenzo in Ponte at San Gimignano; or rather, the head of the Madonna, since in 1413 the fresco was almost entirely redone by Cenni di Francesco: the face survived only thanks to a legend according to which the good state of conservation of Mary's face was the result of a miracle and it should therefore not be touched. Despite the terrible conditions of the painting, the edge of the cloak, the clear veil and the lighter areas of the chin and cheeks are reminiscent of *Madonna* no. 583; but, as Chelazzi Dini has so correctly pointed out, the latter's archaic composition suggests that it must have been painted a few years earlier than the San Gimignano fresco, around 1308-1310.

The *Madonna of Mercy* from Vertine also dates from this period. It is a splendid tempera painting only recently attributed (and not unanimously, at that) to Simone. Here, we can still clearly see the influence of Duccio, especially in the positioning and typology of the characters sheltered under Mary's cloak. But a new spirit prevails: a sense of real space between the heads and a feeling of life and movement in the imposing figure of the Virgin (the drapery folds do not conceal the position of her legs and she is quite noticeably turning in order to embrace all her protégés) are evidence of the evolution of the artist's more archaic ideas towards new forms of expression. The effect of rich and precious ornamentation (a striking feature of the *Maestà*) is reproduced in the use of gold and silver, colourful gems set in the surface, and transparent varnishes. Although we cannot be sure that this Madonna was actually painted by Simone, no one can deny the analogies, both in technique and style, with *Madonna* no. 583.

4. Madonna of Mercy
154 x 88 cm
Siena, Pinacoteca

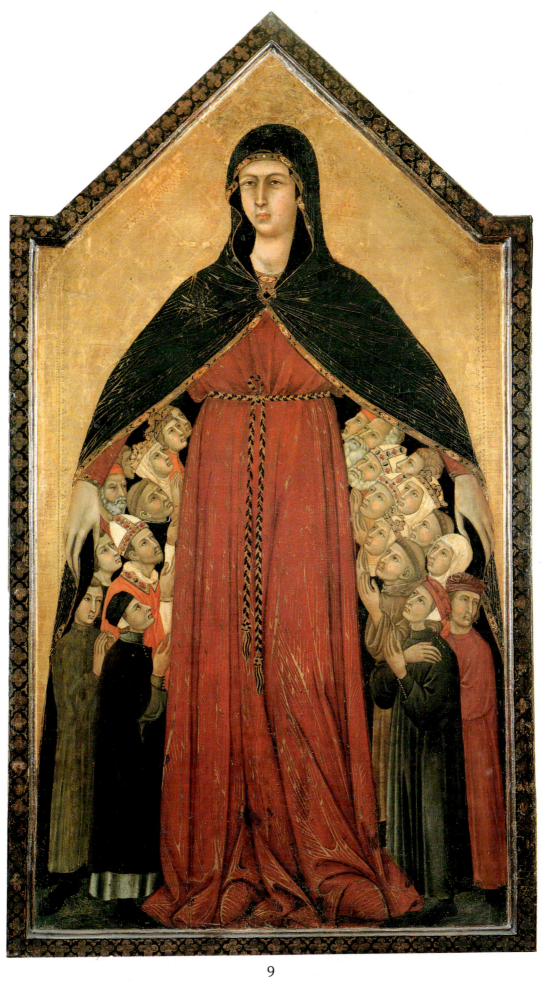

9

Simone and the Commune of Siena: His Fame Grows

In our investigation of the mysteries behind the development of the art of Simone, after the early works that have been attributed to him in a fairly plausible way, although purely on stylistic grounds, we come to a concrete element: the 5 *Maestà* in the Palazzo Pubblico, which is still the oldest painting that we can safely attribute to him. The end wall in the Sala del Mappamondo is entirely covered by this fresco. Surrounded by a frame decorated with twenty medallions depicting 10, 11 the Blessing Christ, the Prophets and the Evangelists (in the corners, each one with his symbol) and with smaller shields containing the coats-of-arms of Siena (the black and white standard) and the Sienese people (the lion rampant), the fresco shows a host of angels, Saints and Apostles, with 9 the Madonna and Child in the centre. To the left of the splendidly decorated throne, Saints 7 Catherine of Alexandria, John the Evangelist, Mary Magdalene, Archangel Gabriel and Paul; to the right, in almost identical positions, Barbara, 8 John the Baptist, Agnes, Archangel Michael and Peter. Below, kneeling, are the four patron Saints of Siena: Ansano, Bishop Savino, Crescenzio and Vittore, accompanied by two angels who are offering Mary roses and lilies. The whole scene, set against a deep blue background, is surmounted by an imposing canopy of red silk, significantly held up by Saints Paul, John the Evangelist, John the Baptist and Peter. In the lower section of the fresco, on the inner frame, are the remains of an 12 inscription which has been reconstructed as follows: "Mille trecento quindici era volto/ E Delia avia ogni bel fiore spinto/ Et Juno già gridava: I' mi rivolto!/ Siena a man di Simone m'ha dipinto" (1315 was over and Delia had made the lovely flowers blossom, and Juno cried: I'm turning over. Siena had me painted by the hand of Simone). There is no doubt that the artist mentioned was indeed Martini, but the interpretation of the date is controversial: some think that it refers to June 1315, others believe that it means June the following year, for 1315 was over, Delia (Spring) had already made the flowers bloom, whereas Juno, to whom the month of June was dedicated, was about to show her second half. The most obvious innovations present in Simone's style, an art that was very different from traditional forms, are his ideas of three-dimensional space. The canopy's supporting poles are placed in perspective, thus giving a sense of depth to the composition. Under the canopy there is a crowd of thirty people: no more processions of people in parallel rows, but concrete spatial rhythms and animated gestures. Simone was quite clearly acquainted with the perspective constructions that Giotto had used in Assisi, an acquaintance that might have come to him through the work of the Master of Figline or that of Memmo di Filippuccio. But his art also contains a personal interpretation of elements of the French Gothic (not necessarily the result of a journey abroad, for he could have seen ivory carvings, miniatures and goldsmithery): the pointed arch structure of the throne, the precious ornamentation of the materials and the golden reflections give the whole scene a vaguely secular mood. But there is something more. Simone has developed a new way of understanding art: the wall is not simply painted, but carved, incised, set with coloured glass, raised surfaces, strong and bright colours. The various materials, like glass, tin and so on — everything that is not tempera or coloured earth — are all handled with great confidence by Simone. As Luciano Bellosi has suggested recently, Simone Martini owes a great deal to the work of Sienese goldsmiths. The Gothic shapes and the sophisticated and shining surfaces were undoubtedly influenced by the artefacts produced in the workshops of goldsmith artisans, who decorated the most precious metals with the new technique of translucid enamels. This tendency towards perfectionism and use of imaginative techniques produces surprising effects. As Alessandro Bagnoli has pointed out, the scrolls held by the Child and by St Jerome are made of paper (and not parchment) and the words are written on them in real ink.

In 1321 Simone Martini and the assistants of his workshop restored the fresco, retouching some of the figures that had been damaged: the faces of the Virgin, the Child, the angels and the patron Saints, Ansano and Crescenzio. The two different periods when Simone worked on the *Maestà* are very important in our reconstruction of the development of his art: the restored sections, with their more linear design and more transparent colours, are much more self-confident than the earlier parts. But let's not forget that between his first intervention and the second one Simone had been to Assisi. And that's not all. Tests carried out recently have shown that in the lower section (more or less at the height of the thighs of the kneeling Saints, about four metres from the floor)

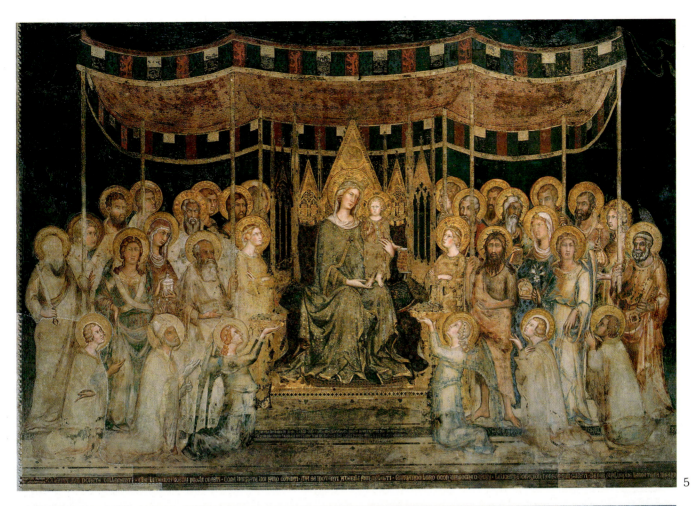

5

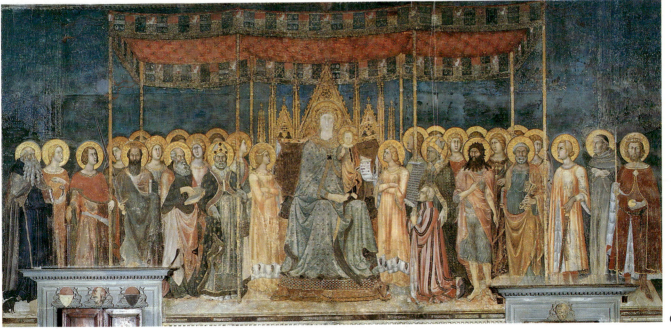

6

5. *Maestà*
763 x 970 cm
Siena, Palazzo Pubblico

6. *Lippo Memmi*
Maestà
San Gimignano, Palazzo Pubblico

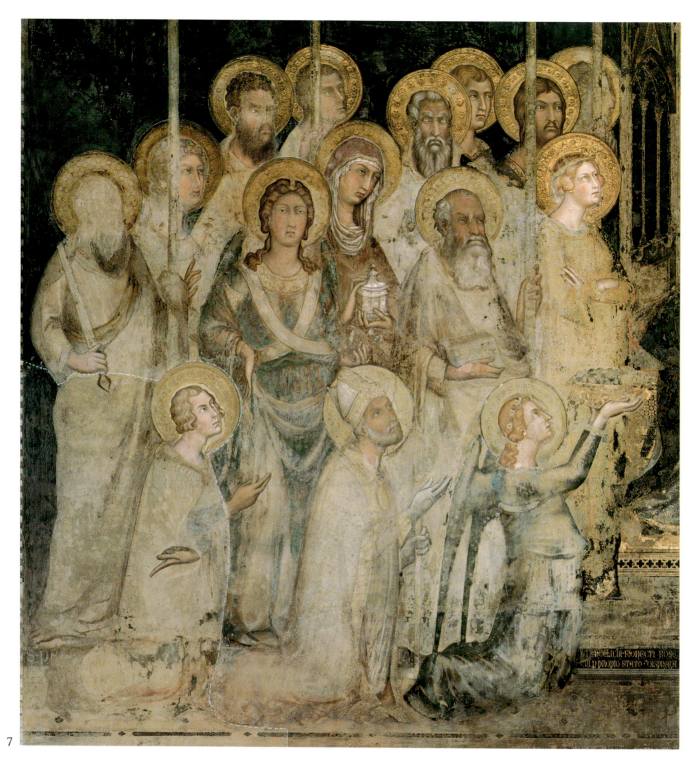

7

there is a clearly visible line where the colour tonality changes. Since it does not look simply like the demarcation between two different days' work, Bagnoli has suggested that it indicates a short period of interruption on the work on the fresco (notice how the intonaco does not blend perfectly, as the result of being applied at different times). Therefore, we can say that even the first painting of the *Maestà* was carried out in two separate sessions. One can but wonder where Simone was while the host of Saints was waiting to be completed, and what superior power (it had to

7. Maestà
Detail of the left side
Siena, Palazzo Pubblico

8. Maestà
Detail of the right side
Siena, Palazzo Pubblico

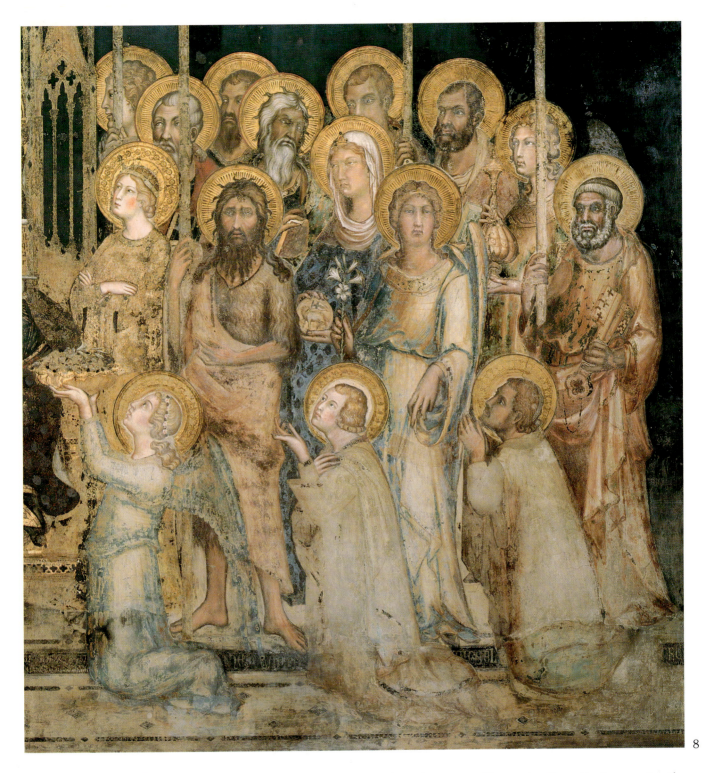

be indeed superior!) had distracted the artist from such an important fresco. He was probably in Assisi, measuring the wall surfaces of the chapel of San Martino, planning the scenes and perhaps even drawing his first synopias on the walls.

The lines in Italian that appear on the steps of the throne are composed in *terzine* rhyme, like the *Divine Comedy*. They explain the meaning of the fresco: the Virgin is addressing the Council of Nine, who had commissioned the fresco, and is exhorting them to govern in the name of those moral and religious principles that guarantee con-

cord and justice. Peace in the city is constantly threatened by internal struggles between the two enemy factions, led by the Tolomei and the Salimbeni. And these Mary condemns: "Li angelichi fiorecti, rose e gigli, / Onde s'adorna lo celeste prato, / Non mi dilettan più ch'e' buon consigli. / Ma talor veggio chi per proprio stato / Dispreza me e la mia terra inganna: / E quando parla peggio è più lodato: / Guardi ciascun cui questo dir condanna. / Responsio Virginis ad dicta sanctorum: / Dilecti miei, ponete nelle menti / Che li devoti vostri preghi onesti / Come vorrete

9

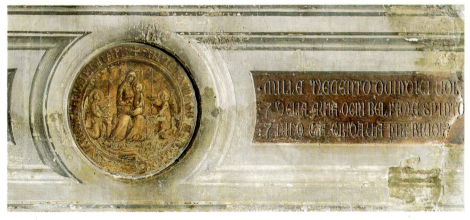

9. Maestà
Detail of the Madonna and Child
Siena, Palazzo Pubblico

10. Maestà
Detail of the medallion with St Gregory
Siena, Palazzo Pubblico

11. Maestà
Detail of the medallion with the Allegory of the Old
and the New Law
Siena, Palazzo Pubblico

12. Maestà
Detail of the medallion with Madonna and Child
Siena, Palazzo Pubblico

voi farò contenti, / Ma se i potenti a' debil fien molesti / Gravando loro con vergogna o danni, / Le vostre orazion non son per questi / Né per qualunque la mia terra inganni" (The angelic little flowers, roses and lilies, that adorn the heavenly meadow, do not please me more than good council. But at times I see men who despise me and betray my land: and the worse they speak, the more highly they are praised: Meditate, each one of you who is condemned by this accusation. The Virgin's response to holy prayers: My beloved ones, remember that your devout and honest prayers, as you request, I shall answer; but if the powerful are wicked with the weak, weighing them down with disgrace and harm, then your prayers are not for those men, nor for anyone who betrays my land). The glorification of the Virgin is the iconographical element on which the painting is based: Mary's function is to protect the city, and the four patron Saints are her intermediaries. The fresco was painted in the room where the government held its meetings to discuss the future of the city: the Nine are the highest representatives of the citizenry and the Madonna's protection must first of all cover them. Political messages in depictions of holy scenes were not a novelty for the Sienese; Duccio's *Maestà*, carried in triumph into the Cathedral in 1311, includes both the patron Saints and a prayer to the Virgin; although in a more veiled way, its purpose was the same. But in Simone the civic and secular content is developed fully: the sacred elements are included in a slightly ambiguous dimension, in which the heavenly court becomes the highest exaltation of a very worldly and real court. Simone's social ideals, "courtly" and aristocratic, are the same as those of his clients: the *Maestà* is both sacred and profane and the courtly gestures of the characters reflect a noble and elitist vision of religion.

Simone and the House of Anjou: Assisi and the Naples Altarpiece

17-43 It was only in the late 18th century that an antiquarian from Gubbio, Sebastiano Ranghiasci, first attributed the frescoes that decorate the chapel of San Martino in the Lower Church in Assisi to Simone Martini. About a century later Cavalcaselle confirmed this attribution and wrote about it in his studies on Italian painting. As far as the dating is concerned, scholars have still not reached an agreement. Bologna's suggestions are probably the most convincing: he believes that the frescoes were finished by early 1317, which is in contrast with the opinion of traditional scholars who always considered them a late work. Although surprising, Bologna's theory is solidly supported by

13. *St Francis and St Louis of Toulouse Assisi, San Francesco*

14. *St Elizabeth, St Margaret and Henry of Hungary Assisi, San Francesco*

15. *Madonna and Child between St Stephen and St Ladislaus 100 x 200 cm Assisi, San Francesco*

13

14

15

stylistic comparisons with the older sections of the *Maestà* and with the contemporary Altarpiece of St Louis of Toulouse (probably painted in 1317) as well as by a careful reconstruction of the historical events involving the House of Anjou (who commissioned the frescoes) and Simone himself around this period.

Bologna has pointed out a discrepancy between the iconography of the fresco cycle (which is clearly a celebration of the life of St Martin of Tours) and the frescoes on the underside of the entrance arch depicting eight saints: as Bologna writes, these figures are like an autonomous cycle celebrating a special event. They were not part of the original programme and were painted in 1317 in honour of St Louis of Toulouse who had just

been sanctified, and the figure of St Louis, with his shining halo, stands out. According to normal decorating procedures, the underside of the arch would have been the last part of the chapel to be frescoed so that by that year (1317) we can presume that the chapel was already painted. Further elements supporting this dating have been supplied by Bellosi in his fascinating studies on late mediaeval clothing: the female costumes, and especially the necklines, are of the shape and size popular in the first twenty years of the century, so that "1317 is more likely to be the year the frescoes were finished, rather than the year in which they were begun." And these eight saints also help us determine the patron who commissioned the frescoes, and not just the date. The in-

16. *Diagram of the fresco cycle in the Chapel of San Martino in the Lower Church, Assisi*
St Louis of France and St Louis of Toulouse (19)
St Clare and St Elizabeth (20)
Burial of the Saint (42)
Miracle of the Resurrected Child (34)
Division of the Cloak (26)
Meditation (35)
Dream (27)

Stained-glass windows (24, 25)
Miraculous Mass (37)
St Martin is Knighted (28)
Death of the Saint (40)
Miracle of Fire (39)
St Martin Renounces his Weapons (31)
St Catherine of Alexandria and St Mary Magdalene (18)
St Francis and St Anthony of Padua (17)

fluence exerted by the House of Anjou is clearly noticeable here: together with Saints Francis, Clare and Anthony (tributes to the Order that administered the Basilica), we find other saints connected to Robert of Anjou. Louis of Toulouse was his older brother; Elizabeth of Hungary was the aunt of his mother, Mary; Louis IX, King of France, was his great-grandfather; Mary Magdalene and Catherine were saints his father Charles II was particularly devoted to (especially Catherine, and stories from her life appear also in the fresco cycle in Santa Maria Donnaregina in Naples, another decoration commissioned by the House of Anjou).

But let us examine the chronology more carefully. The consecration and decoration of the chapel were commissioned in 1312 by Gentile Partino da Montefiore, a Franciscan friar who was made Cardinal with the title of San Martino ai Monti, which explains the subject matter of the cycle — the life of St Martin. Cardinal Gentile left

the friars of Assisi the considerable sum of six hundred gold florins. He had been a powerful prelate, always very active in Church affairs and closely connected to the House of Anjou: it was thanks to his good offices that Robert of Anjou's nephew, Charles Robert, was made King of Hungary. But the relationship between the Anjou of Naples and the Franciscan Order, or more precisely that part of the Order that favoured a more rigid interpretation of the vow of poverty, the Spirituals or Fraticelli, had been good and close for a long time. Louis gave up his throne in order to take his vows in the Order, and he was a very strict observer of the original Franciscan Rule of absolute poverty. The group of saints painted 13, 1 alongside the altar dedicated to St Elizabeth in the right transept of the Basilica is a further expression of the political and religious feeling that bound the House of Anjou to Hungary and the Spirituals. Scholars have found plausible historical explanations for their presence and identified them,

17

18

17. *St Anthony and St Francis*
218 x 185 cm
Assisi, San Francesco

18. *St Mary Magdalene and St Catherine of*
Alexandria
215 x 185 cm
Assisi, San Francesco

although, as Bologna writes, "these figures probably date from about ten years later than the chapel of San Martino and still present many problems that we have yet to solve."

Proceeding from left to right, after Saints Francis, Louis of Toulouse and Elizabeth of Hungary, we find St Margaret: this figure had always been identified as St Clare, until a recent cleaning revealed a small cross, the symbol of St Margaret. Next to her is a young and very beautiful saint, who is probably Henry, Prince of Hungary (and not Louis IX of France, as had been suggested: how could he be a king without a crown?), the son of St Stephen, shown on the next wall with St Ladislaus and the Madonna and Child. The presence of all these members of the House of Anjou in the frescoes in Assisi is justified, in other words, by the close connection existing between

the Order and the royal family, and it is quite suitable that they be placed here, in the chapel of Cardinal Gentile da Montefiore who was both a Franciscan and a good friend of the Anjou.

But let us now describe the frescoes more in detail. Next to the eight saints on the underside of the arch, on the entrance wall we find the scene of the *Consecration of the Chapel*. A mood of deep humility pervades the whole scene and provides the psychological link between the two characters: Cardinal Gentile is shown in humble adoration at the feet of St Martin who is gently helping him to get up. The very ecclesiastical setting, depicted in a perspective seen from below, consists of a splendid ciborium, a Gothic construction with a trefoiled ogival arch and corner pinnacles, and a polychrome marble balustrade in the background. The pictorial decoration continues with ten episodes from the life of St Martin, each surrounded by a frame consisting of geometric ornaments that originally contained inscriptions with commentaries for the scenes; unfortunately, the inscriptions have almost totally faded and are now illegible.

Starting from the entrance, from left to right and from top to bottom, the side walls and barrel-vaulted ceiling are frescoed with the following

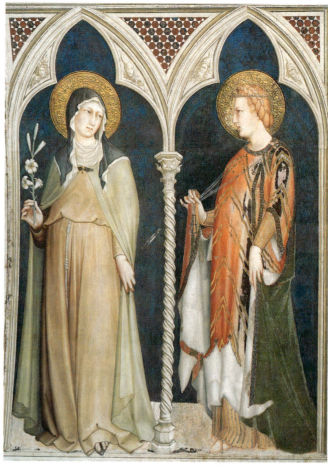

19

20

scenes: on the lower level, the *Division of the Cloak*, the *Dream*, *St Martin is Knighted* and *Renounces his Weapons*; on the middle level, the *Miracle of the Resurrected Child*, *Meditation* (on the ceiling), the *Miraculous Mass* and the *Miracle of Fire* (on the ceiling); on the top level we find the last two episodes, *Death and Burial of the Saint*. Placed inside the small trefoiled aediculae (very similar to the ciborium in the *Consecration*) in the jambs of the two-light windows there are eighteen busts of saints: they are very difficult to identify, especially since the inscriptions have almost totally disappeared. Figures of men of the church alternate with laymen. Those on the central window would appear to be by Simone himself, whereas the others seem to be almost entirely the work of assistants. The stained-glass windows also deserve mention. We know nothing about who actually carried out the work, although it is quite likely that Simone designed them, and they show considerable analogies with the older parts of the *Maestà* in the Palazzo Pubblico and the stained-glass windows in Assisi, so much so that, as Bologna states, "we can assert not only that the windows of the chapel of San Martino date from around 1321, but also that they indicate before his other works in which direction Si-

24, 25

5

19. *St Louis of France and St Louis of Toulouse*
215 x 185 cm
Assisi, San Francesco

20. *St Clare and St Elizabeth of Hungary*
215 x 185 cm
Assisi, San Francesco

21. *Detail of St Elizabeth of Hungary*
Assisi, San Francesco

mone's art will develop in the years to come." The dates suggested by Bologna are based on the dates of external events. In 1321 Gentile da Montefiore not only commissioned the decoration of the chapel, he also spent a few months in Siena: he probably met Simone and chose him as his "personal" painter. The procedures normally followed in the building and decorating of churches also suggest an early date. In areas which were going to be frescoed the windows were put in first, because the coloured glass changed the colour of the lighting, altering the effect of the frescoes. In the lower section of the central window we find Cardinal Gentile and St Martin. The patron of the chapel is shown kneeling in front of the Saint, who is in the act of blessing: this same iconogra-

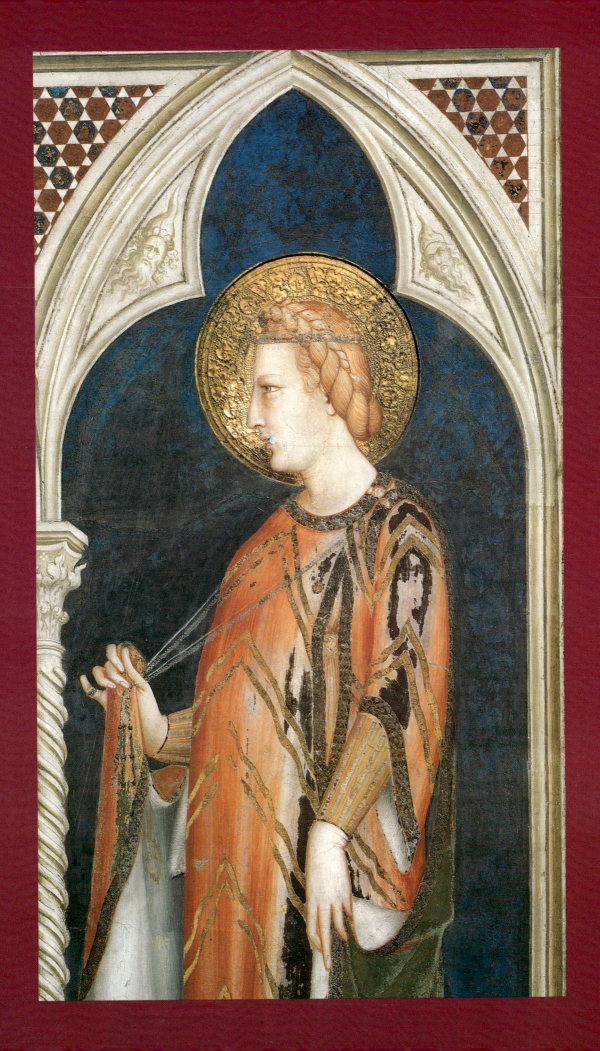

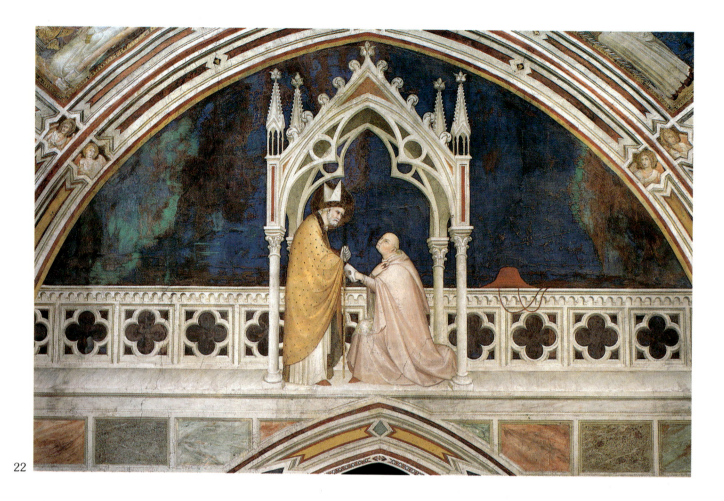

phy will be repeated, with the addition of many
more details, in the scene of the *Consecration*.

The chapel's decoration is completed by a wide
marble wainscoting with white and red inlay that
runs around the bottom of the walls, as well as
vermilion granite columns and ribbing with geo-
metric decorations; the deep blue ceiling is dotted
with gold stars.

The spirit in which the Stories from the Life of
St Martin are recounted is totally new and per-
sonal. The Saint's life unfolds in a lay and secular
atmosphere, with courtly emblems, knights,
grooms and musicians clearly recreating the set-
ting of 14th-century aristocratic Courts, in particu-
lar the Anjou royal palace in Naples. And in any
case the story of St Martin was quite well suited
to this iconographic interpretation; before devot-
ing himself to religious matters, Martin had been
an officer in the Roman army and he would have
continued in his family tradition (his father was an
infantry commander) had he not undergone a
profound religious conversion in 344. The courtly
characteristics of the layman Martin are all includ-
ed and stressed: as well as the scene of the *Inves-
titure*, there are two other episodes depicting Mar-
tin in his role as Roman *miles*. Obviously, the
chivalric element, a fundamental element in the
hierarchical division of mediaeval society, ap-

22. *Consecration of the Chapel*
330 x 700 cm
Assisi, San Francesco

23. *Consecration of the Chapel, detail*
Assisi, San Francesco

pears to be more important than other aspects of
the story. For example, no mention is made of
Martin's period as a disciple, as a hermit, nor of
his monastic life (events that cannot really be con-
sidered minor, especially in the life story of a
bishop saint!). But we must remember the nature
of the patrons who had commissioned the fres-
coes, as well as Simone's innate inclination
towards courtly circles; bearing this in mind, we
can explain the very worldly and mundane
characteristics of the cycle. The four scenes on the
lower level deal with the period in Martin's life be-
fore his conversion in 344. He is portrayed as a
man of the world, dressed as a layman and with
long, flowing hair (his fair hair shows under his
cap in the scene of the *Dream*, too).

The first fresco depicts the famous episode of
the *Division of the Cloak*, the story for which Mar-
tin is best known: having come across a beggar
dressed in rags on a cold winter morning, Martin
gave him half of his cloak. To the left, the city of

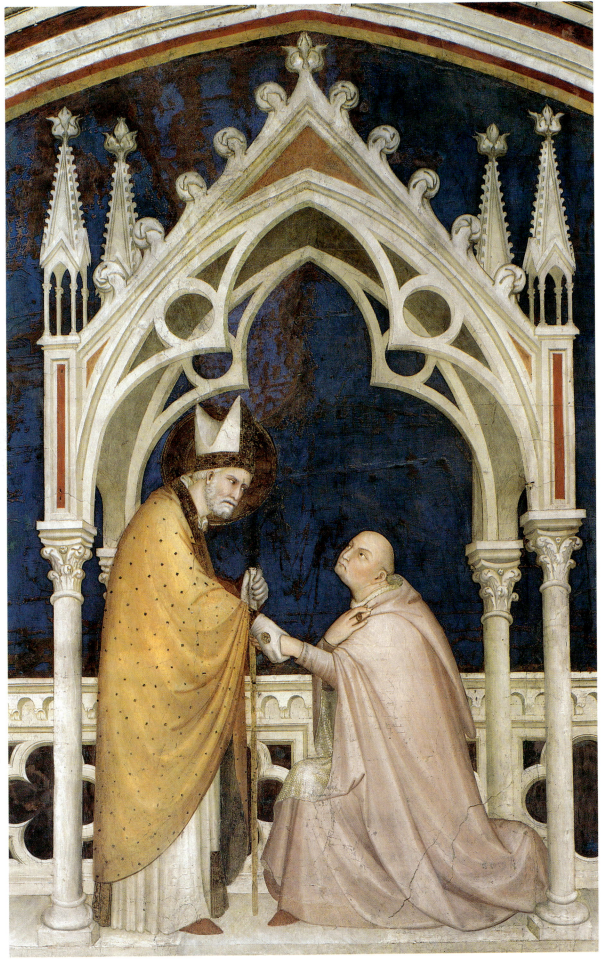

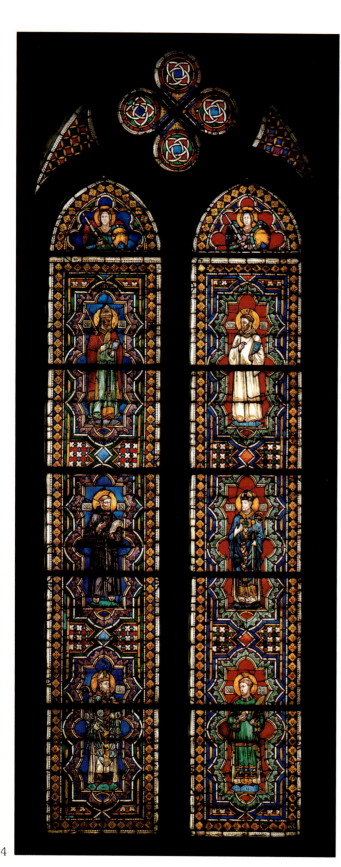

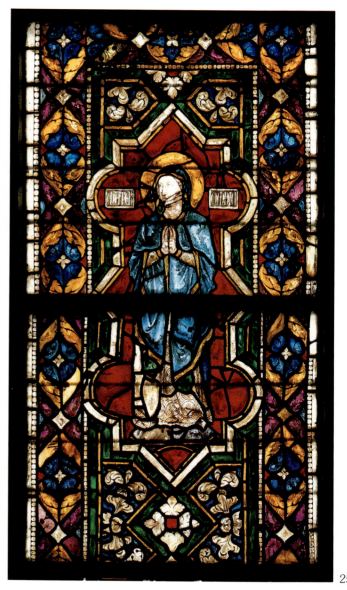

24. *Righthand stained-glass window*
400 x 200 cm
Assisi, San Francesco

25. *Central stained-glass window*
Detail of the Madonna
Assisi, San Francesco

Amiens, where the incident occurred, with its crenellated fortifications and defence towers. To the right, in the upper section, a head: to try and justify this strange presence we must examine the synopia of the fresco in the Museum of the Basilica. Originally Simone had planned the composition differently: the beggar was shown with his arms outstretched towards the cloak and the city gate was on the opposite side. This helps us understand the position of this solitary profile, very close and parallel to the side frame. But then Simone changed his mind, covered the wall with another layer of *intonaco*, drew a new synopia and with a brushstroke of blue paint cancelled that first face which has now resurfaced.

Martin's generous gesture is followed by a *Dream*, in which Christ reveals to him that he was really the beggar. Wrapped in the cloak, and pointing at Martin, Jesus addresses the host of angels accompanying him: some are shown praying, others listen to him with their arms crossed,

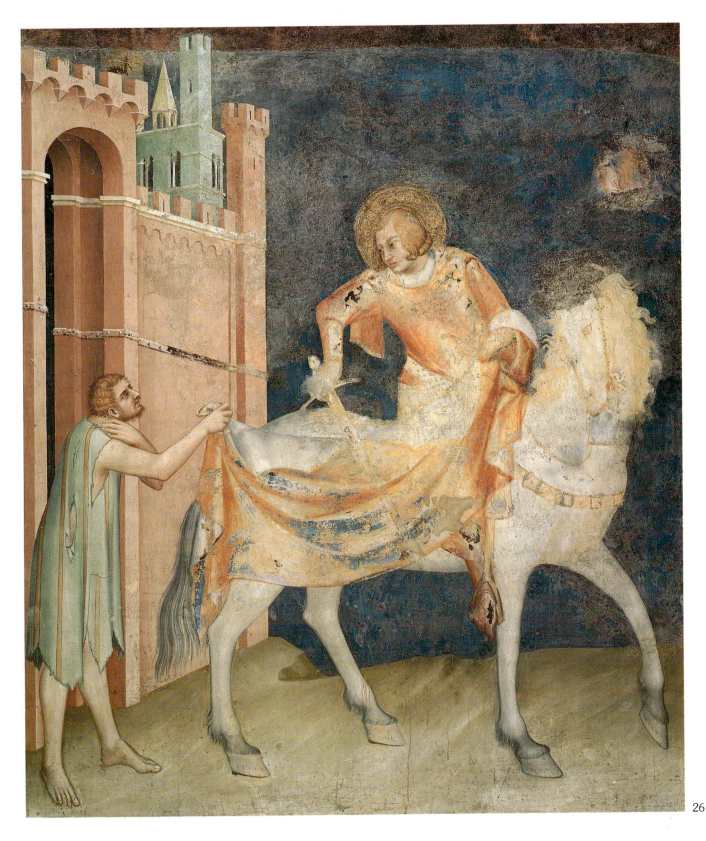

26

26. Division of the Cloak
265 x 230 cm
Assisi, San Francesco

while the mass of gold haloes helps give a sense of depth to the architectural setting. Meanwhile, Martin is sleeping under a blanket of typically Sienese fabric and Simone's realism is evident from one detail in particular: the border of the white sheet and the pillow are decorated with an embroidery called "drawn-thread" work, very fashionable at the time. The rigidity of the out-

25

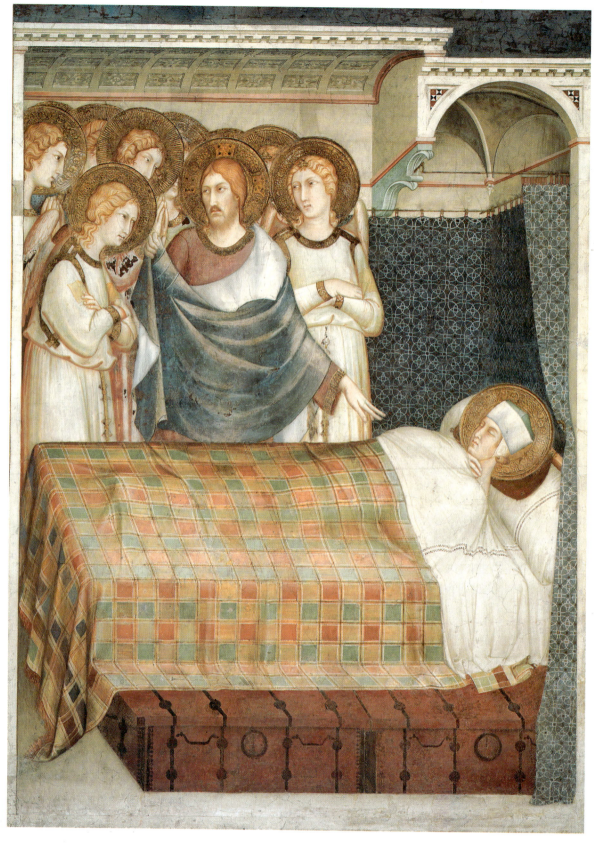

27

27. *Dream of St Martin*
265 x 200 cm
Assisi, San Francesco

28. *St Martin is Knighted*
265 x 200 cm
Assisi, San Francesco

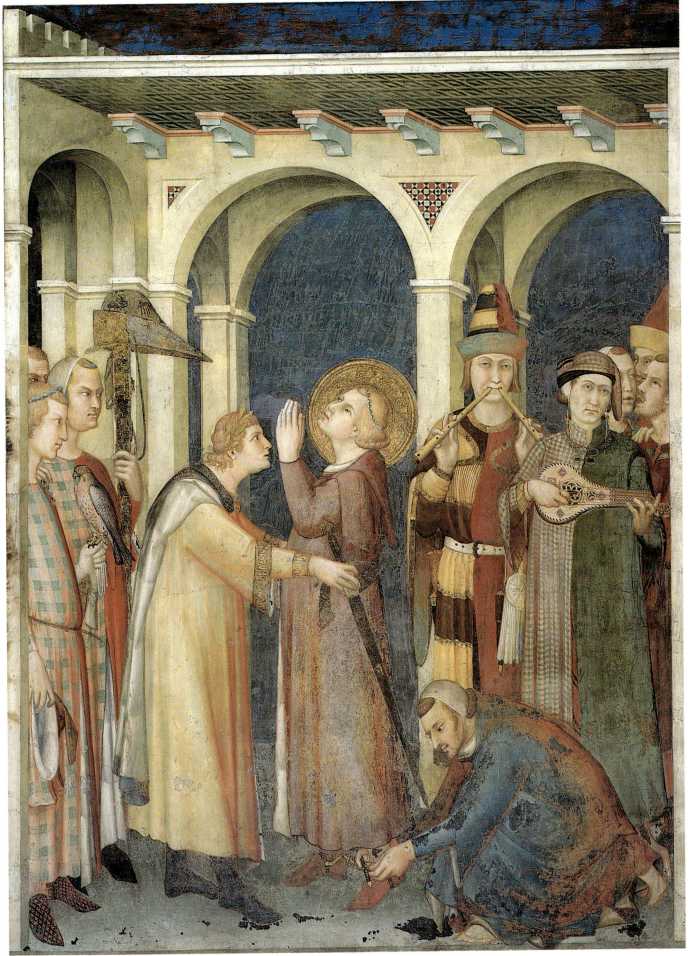

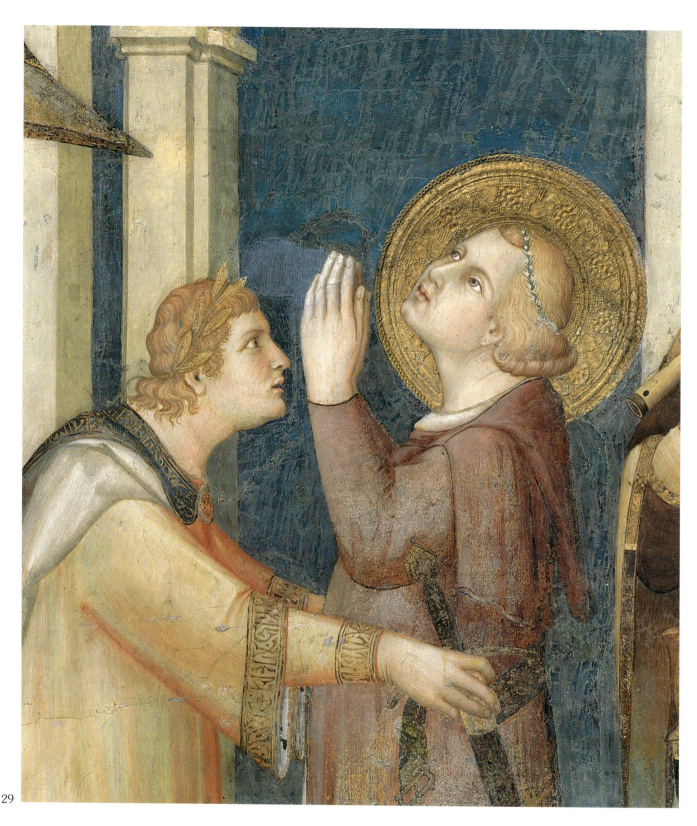

29

stretched body is intended to convey an intense spiritual participation in the message of Christ, and the way Martin's hand rests on his chest reveals excitement, as though he really were listening to the voice of the Lord.

The stories of the life of St Martin that Simone could have used as sources, although none of them mention an actual investiture, do contain references to his military promotions. We can

29. *St Martin is Knighted*
Detail of Emperor Julian and St Martin
Assisi, San Francesco

30. *St Martin is Knighted*
Detail of the musicians
Assisi, San Francesco

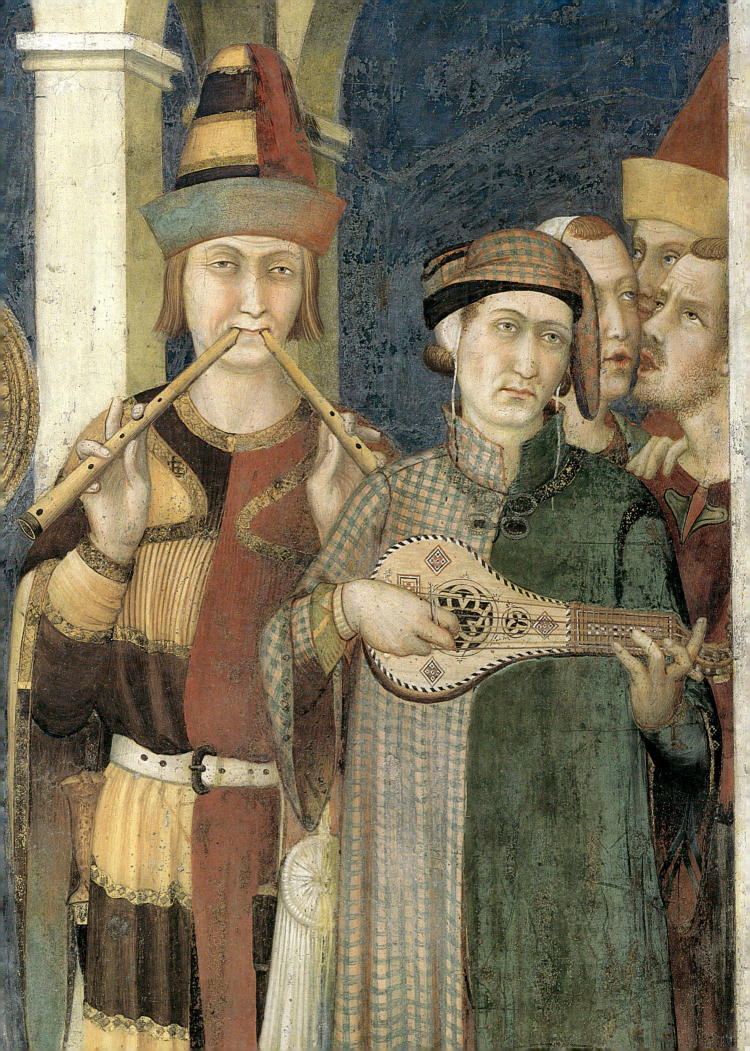

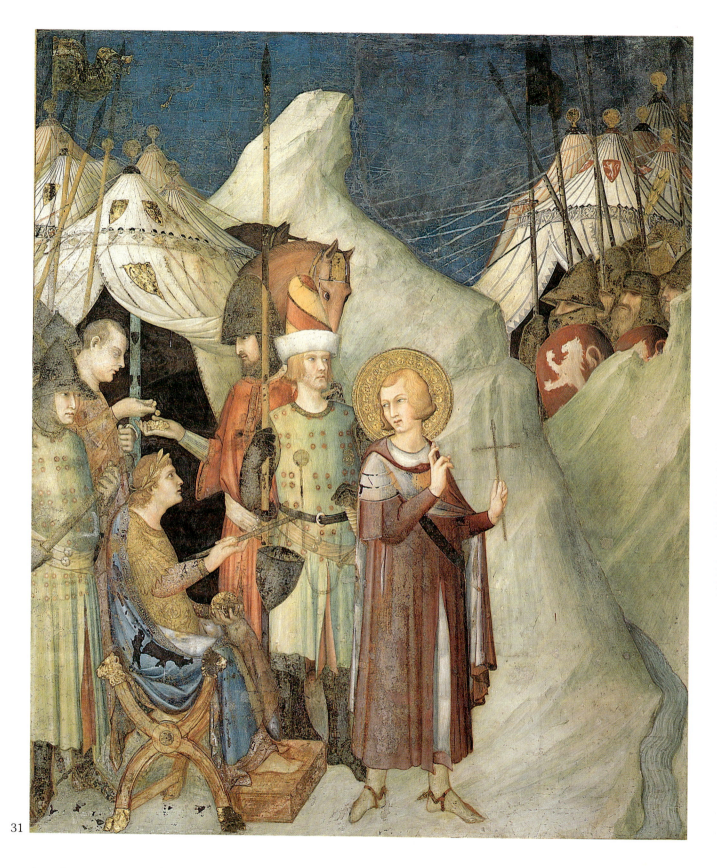

31

31. *St Martin Renounces his Weapons*
265 x 230 cm
Assisi, San Francesco

therefore suppose that our painter, surrounded by a world of tournaments and hunting expeditions, pictured a Roman soldier rather like a mediaeval *miles* and simply transposed a ceremony typical of his times to the late classical world. It is not merely a matter of Panofsky's "theory of distance," according to which mediaeval painters

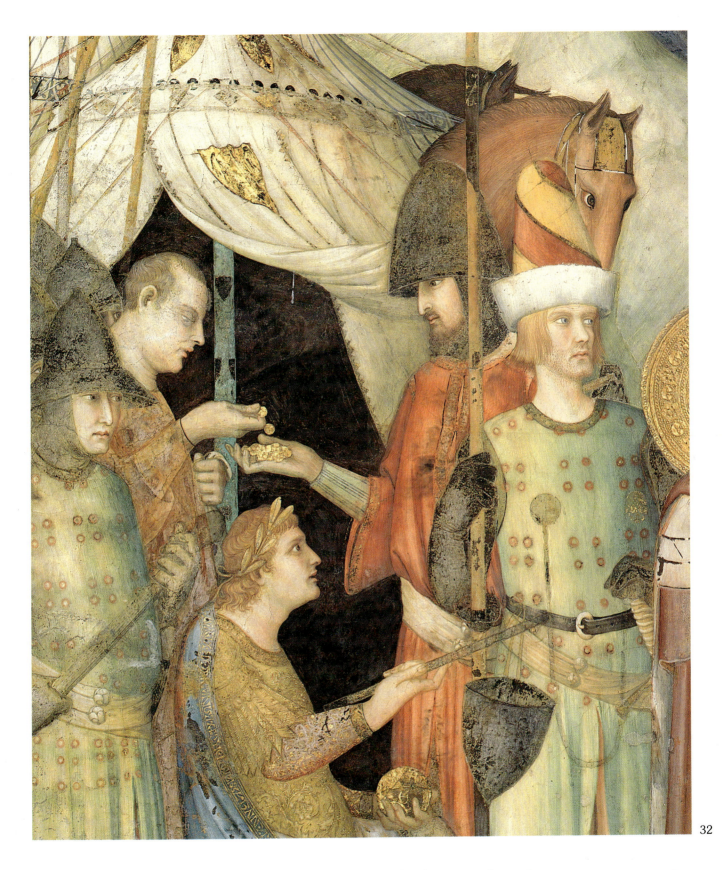

32. St Martin Renounces his Weapons
Detail of the Emperor with his soldiers and
treasurer
Assisi, San Francesco

made characters from the past appear more im-
mediate and closer to their public by placing them
in Gothic architectural settings and dressing them
in 13th-century costumes. Simone (and even
more so his patrons who had commissioned the
frescoes) used the scene of Martin's investiture to 28
focus attention on courtly and aristocratic cus-

31

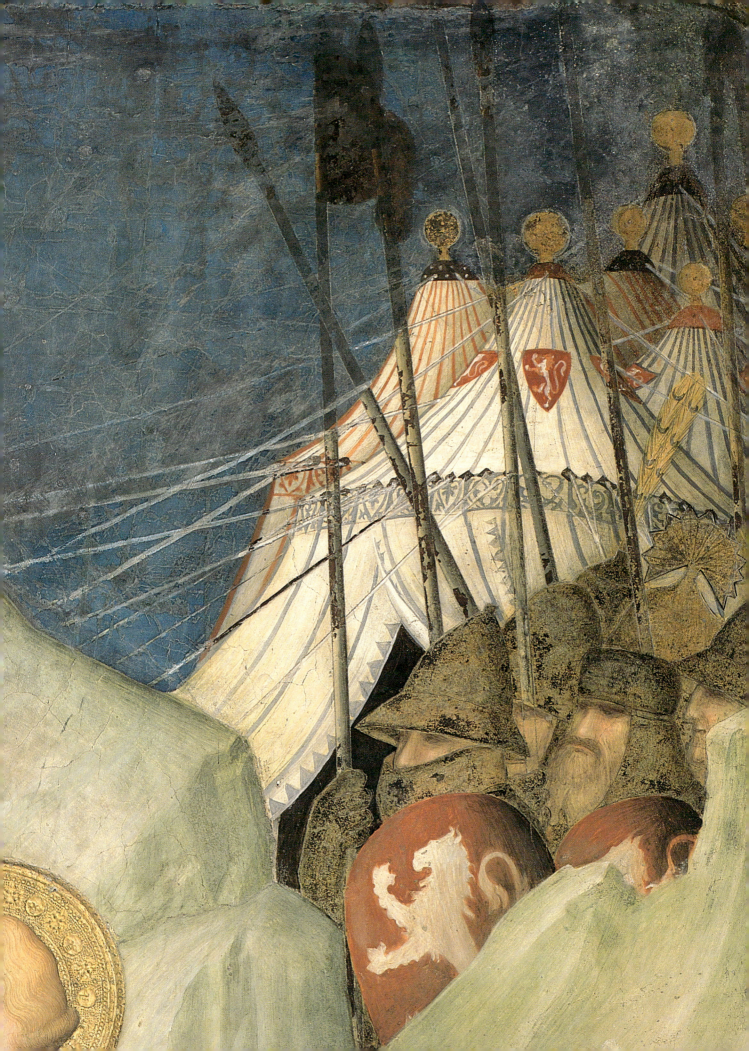

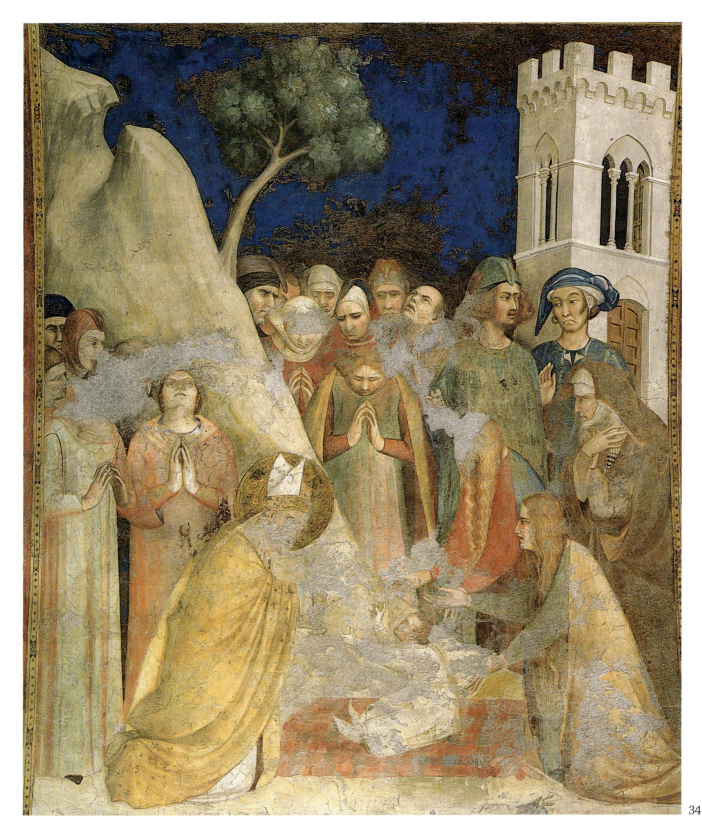

34

33. *St Martin Renounces his Weapons*
Detail of the camp
Assisi, San Francesco

34. *Miracle of the Resurrected Child*
296 x 230 cm
Assisi, San Francesco

toms. Musicians, singers, equerries with weapons 30
and falconers all witness the scene taking place in-
side a palace with loggias and wooden ceilings.
Nothing could be more secular than the figure of
the Roman Emperor fastening the sword, the 29
symbol of his newly acquired dignity, around the
knight's waist. The Emperor's immobile profile,
with his half-open mouth and fixed gaze, is

35

35. *Meditation*
390 x 200 cm
Assisi, San Francesco

36. *Meditation*
Detail of St Martin
Assisi, San Francesco

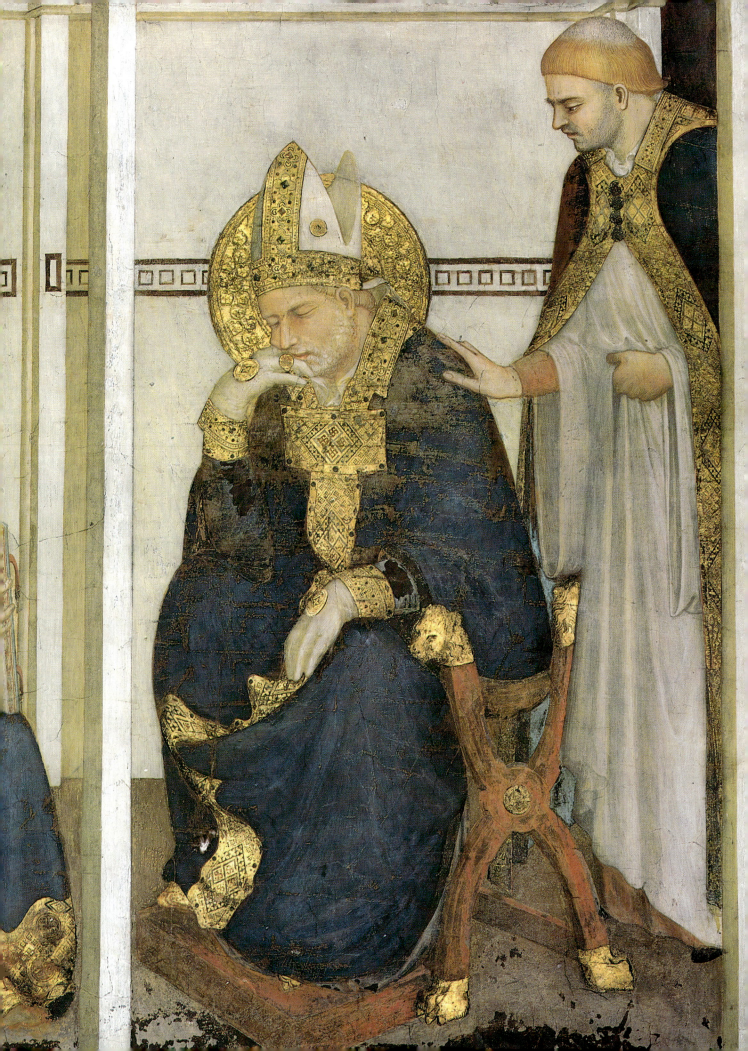

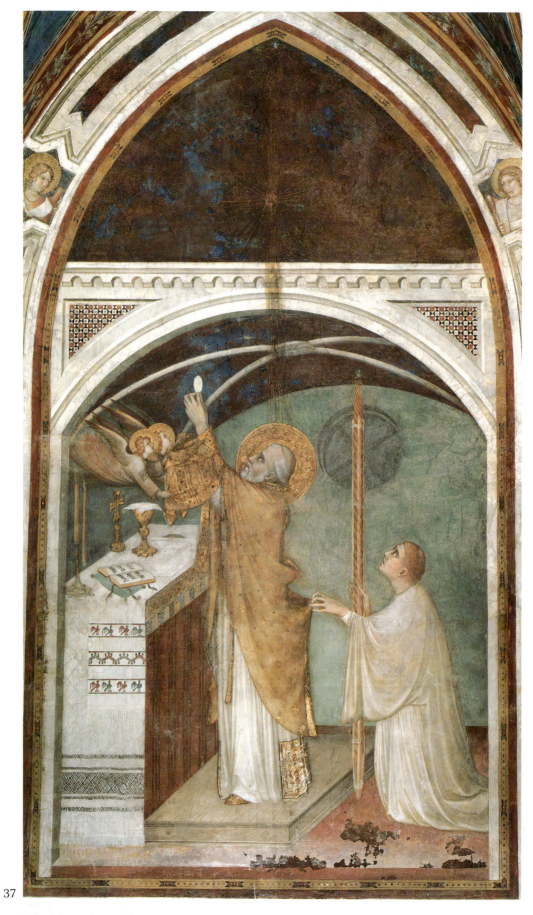

37

37. *Miraculous Mass*
390 x 200
Assisi, San Francesco

38. *Miraculous Mass*
Detail of the elevation of the host
Assisi, San Francesco

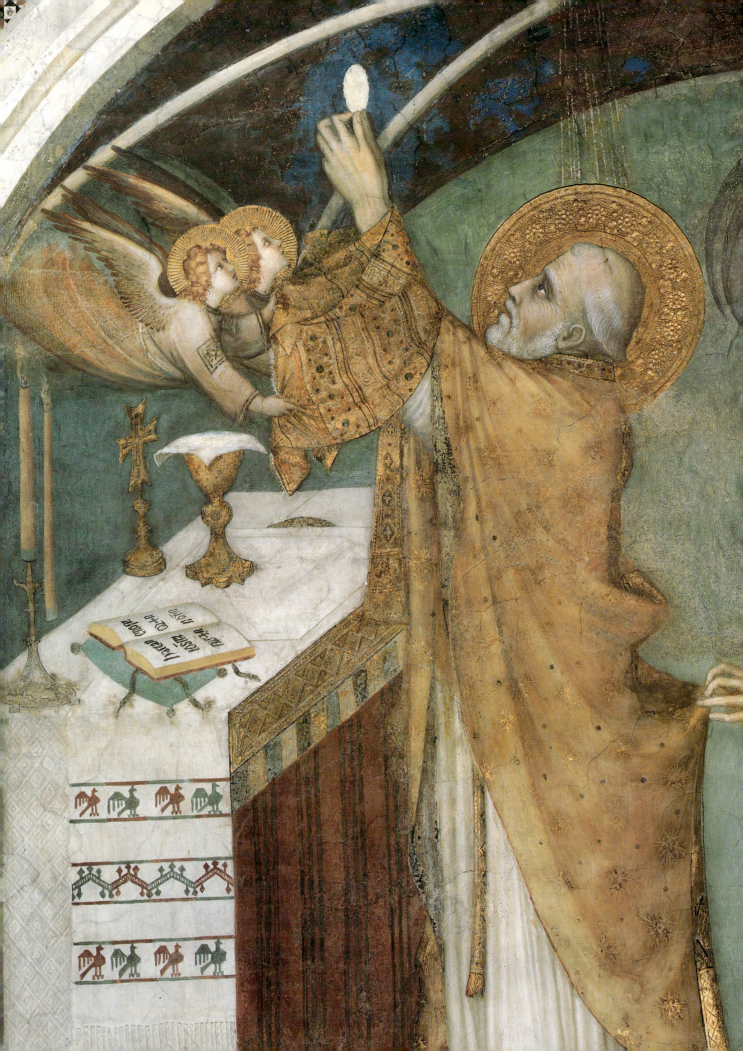

reminiscent of the portraits carved on ancient Roman coins, which Simone probably used as a model: even though it must be Julian the Apostate (and historically it could not be any other emperor), it has been suggested that the features are actually those of Constantine the Great.

31 In the next fresco we see Martin, as an officer in the Roman army face to face with the enemy, announcing his decision: "I am a soldier of Christ and I cannot fight." To the left, the Roman camp, 32 with Emperor Julian, a group of soldiers and the treasurer distributing money to the mercenaries. To the right, waiting for the battle, behind the hill, 33 the barbarian army with their armour and their spears. Martin (still a knight, but carrying a cross and shown in the act of blessing) is looking towards the Emperor but walking towards the enemy. His battle is the struggle against paganism, and his only weapon is the word of Christ.

The episodes depicted in the middle level illustrate the last part of the saint's life, after 371 when Martin was nominated Bishop of Tours, as we can see from his mitre. In the bay to the left of the en-
35 trance we find the scene of the *Meditation*. In a state of profound spiritual ecstasy, Martin sits on 36 a simple faldstool (the same one that Emperor Julian was sitting on in the scene of Martin 31 renouncing arms), while two acolytes try to bring him back to reality so he can celebrate mass in the chapel nearby: one of them is shaking him gently, and the other is handing him his missal. The two architectural spaces, parallel but of different depth, are geometrically so simple and bare that they appear to reflect the Saint's mood of profound absorption in prayer: the only decorative elements are the horizontal Greek key design on the wall and the quatrefoiled ornament in the arch above the mullioned windows.

In the bay to the right we find the scene of the 37 *Miraculous Mass*, an episode that is only very rarely included in Italian fresco cycles. This was the first time it was depicted. The event took place in Albenga and was similar to what happened in Amiens. After having given a beggar his tunic, 38 Martin is about to celebrate mass. During the elevation, the most deeply spiritual moment in the mass, two angels appear and give Martin a very beautiful and precious piece of fabric. There is extraordinary spontaneity and beauty in the deacon's expression of surprise, in his almost fearful gesture: his astonishment is so great that he instinctively reaches out towards his bishop. The scene is a masterful composition of volumes and shapes with the linear elements (the candlesticks and the decoration of the altar-cloth) alternating with the solid structures of the altar and the dais, beneath a barrel-vaulted ceiling.

To the left of the *Meditation* is the fresco of the 36 *Miracle of the Resurrected Child*; like the 34 *Miraculous Mass*, this episode had never been in- 37 cluded in a fresco cycle before. While Martin is praying he is approached by a woman holding her dead child in her arms; she begs him to do something and the Saint kneels in prayer. Amidst the astonishment of those present the child is resurrected. Joel Brink has pointed out that Simone does not follow the official biographies (which all report the incident as having taken place in the countryside around Chartres), but blends this event with a legend that was popular in Siena at the time. This legend was a long-standing oral tradition, which we know of from a 1657 source; it tells the story of Martin stopping in Siena while on his way to Rome on a pilgrimage. In Siena he performed a miracle so great that a church consecrated to him was built in the city. The miracle was a resurrection and this is the connection that justifies Simone's blending of the two episodes and changing the setting to Siena. The city centre is symbolized by the building to the right: the square-topped battlements, the three-light mullioned windows on the piano nobile and the Sienese arch above the entrance door help us identify it as the Palazzo Pubblico. This is how the town hall appeared before 1325 when the bell tower, the Torre del Mangia, was added to the left. The need to make the event recounted more immediate, to modernize an episode that had occurred almost a thousand years before, made Simone go even further. The crowd does not consist only of pagans, as the written accounts of the event described it; Simone portrays a most varied group of onlookers. A plump friar is shown looking up at a tree above the scene: he looks very much like Gentile da Montefiore. Some of the figures are praying devoutly, while others, such as the knight in the blue hat, express astonishment and even scepticism (notice how the other knight looks at him frowning, as though in reproach).

In the scene next to the right bay Simone has painted the *Miracle of Fire*, a fresco which, like 39 the scene of the resurrected boy, is very badly damaged. The scene illustrates the event immediately after the miracle, when a tongue of flame burst down from Emperor Valentinian's throne after he had refused to grant audience to the Saint. The sovereign, more 14th-century than his colleague Julian, is shown stretching out towards Martin, as though about to embrace him. The figure at the far left is very natural, covering his mouth with his hand in astonishment. The scene

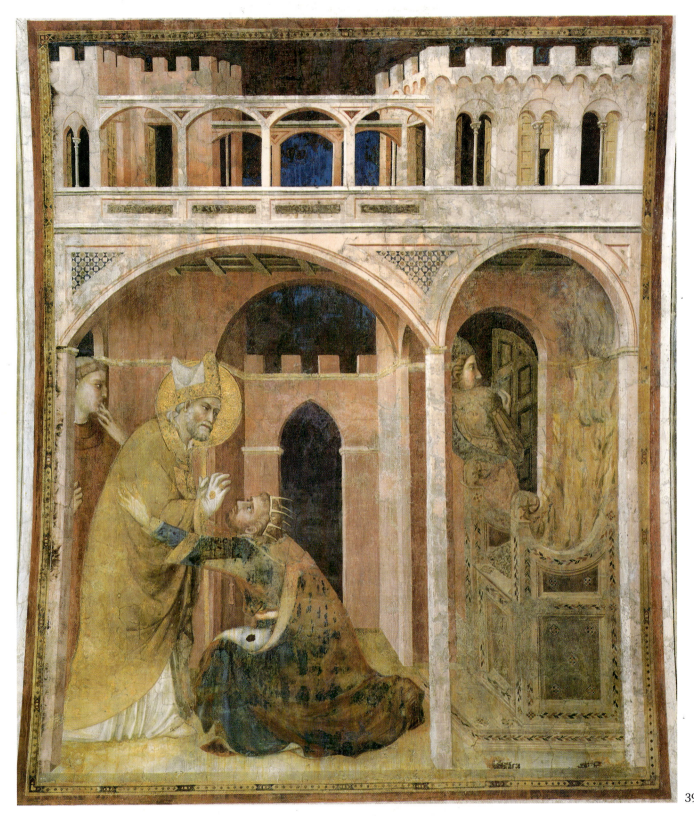

39. *Miracle of Fire*
296 x 230 cm
Assisi, San Francesco

is composed of several different architectural structures, including a variety of arches: pointed arches, round arches, four-centred arches. The two-light mullioned windows also appear in two versions: the ogival Gothic variety and the more typically Romanesque. The pilasters, battlements and loggias create an effect of movement and dynamism.

The frescoes of the *Death* and *Funeral* on the 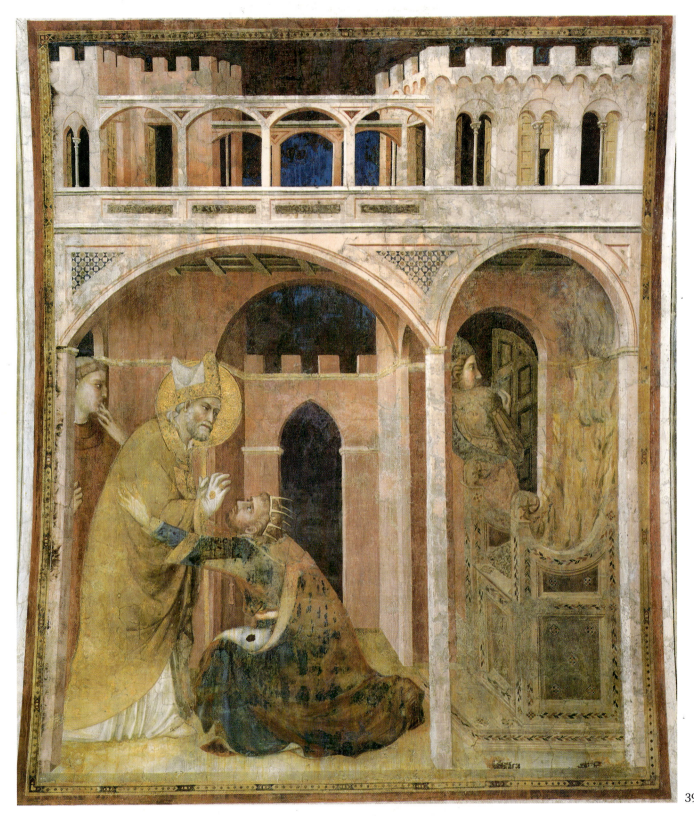 40, 42

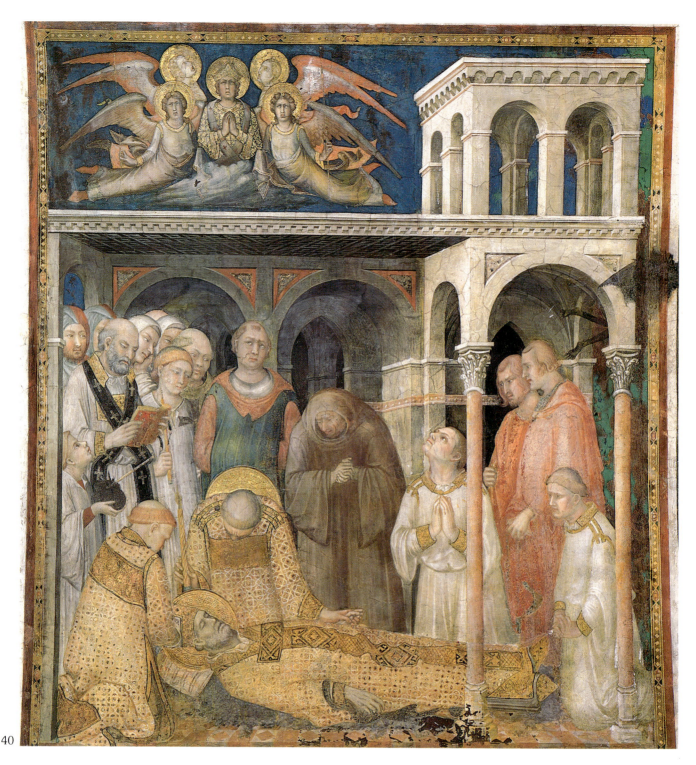

40

upper level are the last scenes of the cycle. Animated by light, colour and spatial depth, both these scenes have the same composition, with a crowd of acolytes and followers witnessing the events. The same characters, with the same features but depicted in different poses and with different gestures appear in both scenes: the priest celebrating the ritual of the deceased in the scene of Martin's *Death* appears in the fresco of the *Funeral* between the two figures with haloes; the tonsured acolyte dressed in green and red who in the *Death* is gazing meditatively upwards, in the

40. *Death of St Martin*
284 x 230 cm
Assisi, San Francesco

41. *Death of St Martin, detail*
Assisi, San Francesco

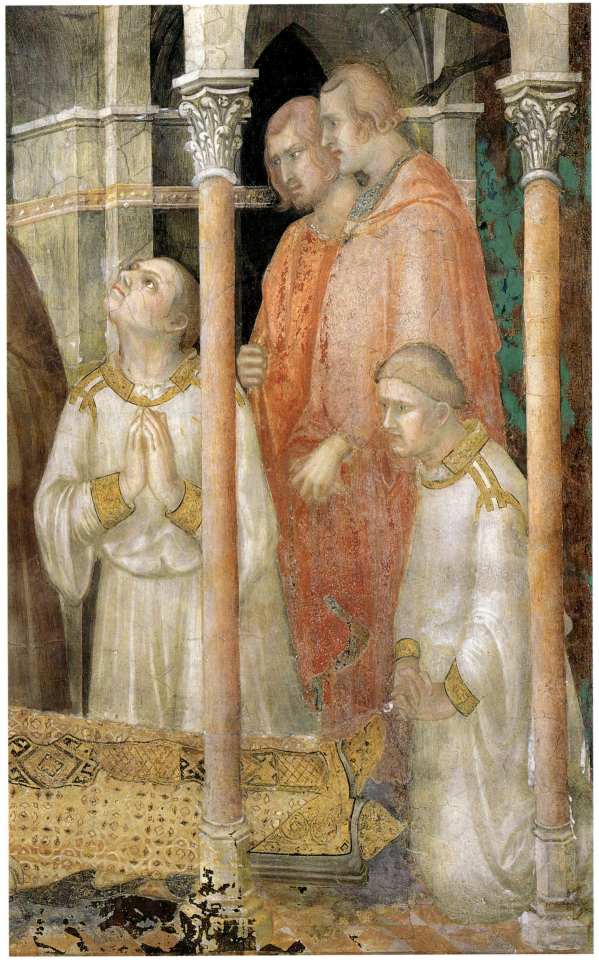

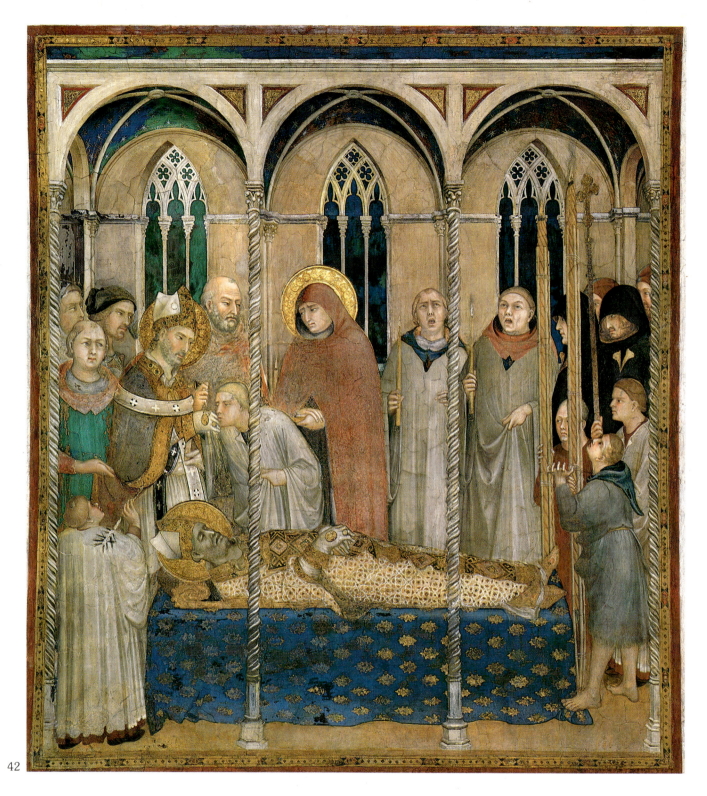

42

Funeral is shown holding the celebrant's dalmatic. And lastly, notice how much the knight under the little aedicula in the fresco of Martin's *Death* looks like the portrait of Robert of Anjou in the *Naples Altarpiece*. Another interesting element is the way the architectural style of the scenes follows the mood of the events: while the building in the scene of the *Death of St Martin* is a severe geometrical structure with bare walls, the *Funeral* takes place in a Gothic chapel with graceful and delicate decorations.

41
45

42. Burial of St Martin
284 x 230 cm
Assisi, San Francesco

43. Burial of St Martin, detail
Assisi, San Francesco

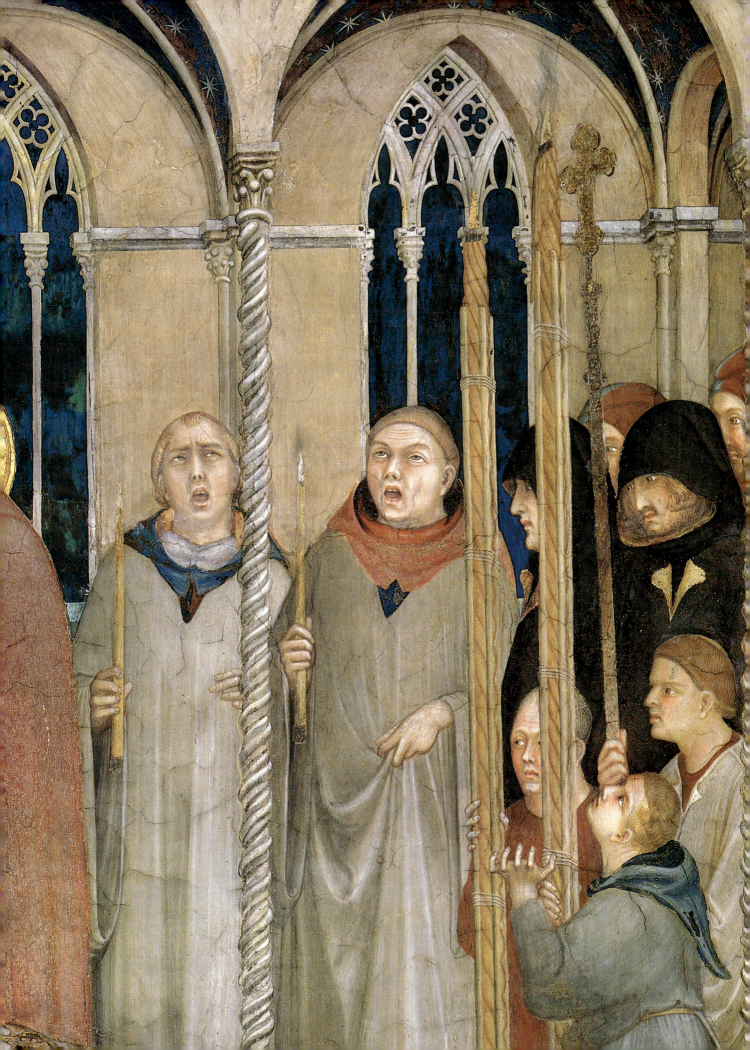

The most important and noticeable element in these frescoes is the spatial construction of each scene. As far as the construction of volumes and perspective is concerned, Simone certainly owed a great debt to the Florentine Giotto. The Stories from the Life of St Francis in the Upper Church in Assisi are the prototype of the spatial organization of the cycle of the life of St Martin. And Giotto's influence is noticeable in the subject-matter of the frescoes as well. Some of the episodes of the story of St Martin (*Division of the Cloak*, *Martin Renounces his Weapons*, *Miracle of Fire*) are clearly modelled on scenes from the Franciscan cycle (*Francis Donates his Cloak*, *Renounces his Worldly Possessions*, *Trial by Fire*), as though Simone wanted to attribute to Martin the role of predecessor of the more recent mediaeval Saint. Giotto's compositions become almost involuntary quotations in these frescoes, but Simone does not simply use and exploit this great model, he elaborates on it and transforms it. The art of the northern Gothic civilization attracts Martini and draws him into a new world of sophisticated colours and lively naturalism which, thanks to his talented personal interpretation, succeed in creating effects of wondrous beauty.

St Louis of Toulouse Crowning Robert of Anjou

There is considerable stylistic similarity between the Assisi frescoes and the painting of *St Louis of Toulouse Crowning Robert of Anjou*, now in the National Museum of Capodimonte in Naples but formerly in the Franciscan monastery of San Lorenzo Maggiore. Probably painted in 1317 on the occasion of the canonization of Louis, Bishop of Toulouse, the altarpiece shows the scene of the coronation set in a lilied frame with a truncated cusp and a predella panel with five scenes illustrating episodes from the Saint's life. The painting actually depicts a double coronation and its iconography is strongly celebratory: while Louis is offering the worldly crown of the Kingdom of Naples to his brother Robert (he himself had renounced the crown in order to take his vows), he receives the heavenly crown, the symbol of his sanctity. On the one hand Simone is stressing an event of great spiritual value, while on the other he does not forget to draw attention to a gesture of political significance. And the scene is actually described like an investiture, with lavishly decorated costumes; the coat-of-arms of the French kings and the great quantities of gold used in the decorations exalt the solemn and formal nature of the gesture.

The predella scenes, on the other hand, are much more lively and realistic; their animated narrative quality is more like the St Martin cycle. Bologna has studied these scenes carefully and we shall follow his interpretation of them. From left to right, in the first panel we find Louis accepting the nomination to Bishop of Toulouse on condition that he be allowed to enter the Franciscan Order. This event took place in secret in Rome in December 1296, in the presence of Boniface VIII; Louis's father, Charles II, for political reasons

44. St Louis of Toulouse Crowning Robert of Anjou
Detail of the predella
Naples, National Museum of Capodimonte

45. St Louis of Toulouse Crowning Robert of Anjou
200 x 138 cm
Naples, National Museum of Capodimonte

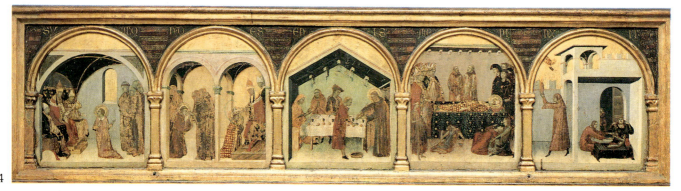

44

wanted his son to become Bishop of Toulouse, for he needed to have direct control over an area that was particularly important for the King of France, Philip the Fair. And who could be a more trustworthy Bishop than his own son? But Louis had already given up his throne in order to follow the example of St Francis, and he had no intention now of becoming a pawn in a political manoeuvre, for this went against his spiritual aspirations; so, in return for accepting this religious office (which was not religious at all. . .), he requested to be allowed to enter the Franciscan Order. In the following panel Louis publicly takes his vows and is consecrated Bishop: this is the official conclusion, on 5 February 1297, of the secret agreement made between Pope Boniface and the Saint. The third scene is based on the proceedings for the canonization of Louis in 1308: with great modesty, the Bishop Saint served and fed the hungry. These scenes relate perfectly to the subject-matter of the altarpiece, the coronation of King Robert, for they exalt the humility of Louis: he is humble because he gave up his throne, he is humble in the presence of Boniface VIII, he is humble in his daily life. But the truth was different. Even more important than his humility, Louis was poor: poor like St Francis, poor like the unpopular Spirituals, and above all poor unlike a King's son, especially one who was a Bishop and had just been canonized. The patron who commissioned the painting (Robert of Anjou, Mary of Hungary, or any other member of

the royal family) clearly requested Simone to conceal, or at least not to emphasize, this aspect of the Saint's virtue; he was to celebrate another aspect of it, equally valid from a spiritual point of view, and totally innocuous politically: Louis is a follower of Christ in his humility, not in his poverty. After the scene of Louis's *Funeral*, depicted as a magnificent ceremony worthy of a high prelate (actually, it appears that it was an austere and simple service), in the last panel we find the scene of a miracle involving a small child: a man prays with a statuette of St Louis in his hands asking for his intervention and his child, who had died shortly before, miraculously comes back to life. With its lively narrative quality and especially because of the iconography involving the death of a child, this scene is very similar to the episodes depicted in the altarpiece of the *Blessed* 60 *Agostino Novello*. The spatial construction of the altarpiece, both in the main panel and in the predella scenes, shows a very conscious elaboration of Giotto's methods, which Simone had already used in the Assisi frescoes. The drapery of the cope, the lion's feet on the faldstool half-hidden by the dais, the geometric patterns on the carpet, as well as the arcades, loggias and the shadowy areas in the episodes below, are the product of very subtle perspective observations which reveal to what extent Simone had by this stage developed a mature approach to spatial construction and the reproduction of volumes.

Simone and his Workshop

By the end of the second decade of the 14th century Simone's fame had spread beyond the walls of Siena, and his art, which had incorporated the new northern trends that transformed even the most devout moods into worldly scenes, had developed its own recognizable style. A large group of followers, who worked together in a workshop, gathered round the illustrious figure of the master and his fervent entrepreneurial ability. For many years the artists of his workshop continued to imitate the style and innovations of Simone: his brother Donato and his future brothers-in-law Lippo and Tederico Memmi are the only ones whose name has come down to us. Alongside them there was certainly a large number of other artists and assistants who worked together as a composite team and produced the paintings of

the so-called "Simone Martini school." It would appear that already as early as the years when Simone was working on the Siena *Maestà* and the 5 Assisi frescoes the master's collaboration with his assistants was very intense, for in 1317 Lippo painted a remarkably faithful copy of Simone's 6 *Maestà* in the Palazzo Comunale in San Gimignano, in which he followed Martini's style practically to the letter. It also appears that the polyptych mentioned by Vasari was painted around this time for the church of Sant'Agostino in San Gimignano. For a long time it was thought that this polyptych had been destroyed but recently a

46. Polyptych
Cambridge, Fitzwilliam Museum

47

group of scholars have reconstructed its original appearance and traced the various pieces in several museums and collections throughout the
47 world: the central panel was the *Madonna and Child* now in the Wallraf-Richartz Museum in Cologne, while the side panels are the three
46 panels in the Fitzwilliam Museum in Cambridge and a *St Catherine* in an Italian private collection. The design of the polyptych with all the panels on a single register, the round-arch shape of the panels, as well as a rather archaic solidity of the figures and their severe and solemn rhythms, all

47. Madonna and Child
79 x 56 cm
Cologne, Wallraf-Richartz Museum

48. Polyptych
Pisa, National Museum

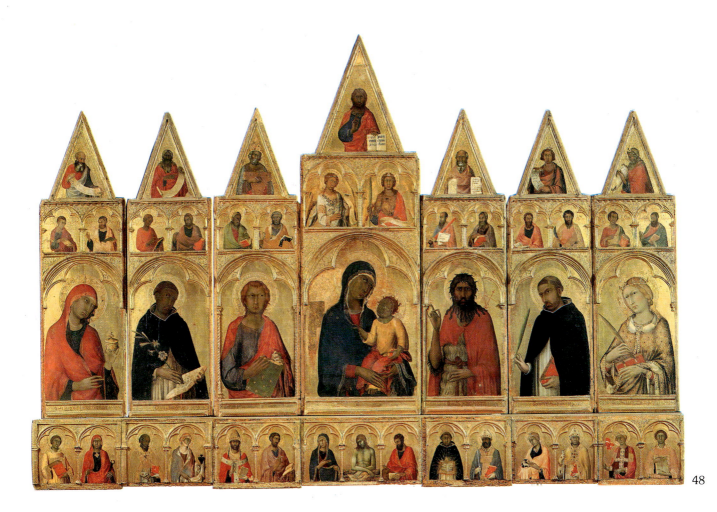

48

suggest a fairly early dating: after Assisi (and there
17-20 is a great similarity with the saints on the under-
side of the arch), but undoubtedly before the
48 more Gothic *Pisa Polyptych*. Scholars almost

unanimously agree that this polyptych is the auto-
graph work of Simone, who probably also paint-
ed a *Blessing Christ* to be placed above the central
panel.

The Polyptych of Santa Caterina

From the "Annales" and the "Cronaca" of the
convent of Santa Caterina in Pisa we learn that in
1319 "Frater Petrus Conversus" ordered that a
very beautiful painting done by "manu Symonis
senensis" be placed on the high altar of the
48 church. This polyptych, now in the Museum of
San Matteo, is without doubt the most important
and grand of Simone's signed paintings: forty-
three busts of apostles, martyrs, bishops and
prophets are placed in the cusps and under the
trefoiled arches of the panels. The altarpiece con-
sists of seven elements, each one in three parts:
a cusp, a smaller panel divided into two sections,
and a larger panel depicting a single saint. There
is also a predella consisting of seven smaller size
panels.

Over the centuries the polyptych has been
reconstructed according to many different the-
ories, but presently it is arranged as follows: in the
cusps, next to the Blessing Redeemer, we find
David playing the harp, Moses with the Tables of
the Law and the prophets Jeremiah, Isaiah,
Daniel and Ezechiel. On the level below, on either
side of the Archangels Gabriel and Michael in the
middle, we find the apostles, arranged in pairs be-
low trefoiled arches: each one is carrying a copy
of the Gospel and is identified by an inscription on
the gold background. From left to right, Thad-
daeus, Simon, Philip and James the Less, who
are talking animatedly about the Scriptures; they
are followed by Andrew and Peter. Then, on the
other side of the archangels, Paul and James

49

49. Polyptych
Detail of Saints Mary Magdalene, Dominic and
John the Baptist
Pisa, National Museum

Major (a shell in relief has been placed between the letters of his name); Matthew writing his Gospel, resting the book on the frame of the panel, together with Bartholomew, followed by Thomas and Mathias. On the middle level, together with Mary Magdalene, St Dominic, John the Evangelist, the Madonna and Child (and above the frame there is the inscription "Symon de Senis me pinxit"), and John the Baptist, we find Peter Martyr and Catherine of Alexandria.

The reconstruction of the predella, on the other hand, is much more certain. It revolves around the central panel where the Man of Sorrows is assisted by the Virgin and St Mark. At the sides, from left to right, we find Saints Stephen and Apollonia, Jerome and Lucy (?), Gregory and Luke, Thomas Aquinas and Augustine, Agnes and Ambrose, Ursula and Lawrence.

With a composition so full of movement, the *Pisa Polyptych* is extremely innovative, especially in its structure. The seven elements, the predella panels and the ones on the upper level, each consisting of two sections, not only allow the artist to include a vast number of characters, but they also allow him to describe each one with a wealth of iconographical details. For this reason, alongside characters who would traditionally be included in any polyptych, we also find figures connected to the religious Order who commissioned the altarpiece: Jerome, Gregory and Augustine as well as

more recently canonized saints, such as the founder of the Order, Dominic, and Peter Martyr. Notice that Thomas Aquinas is portrayed with a halo, whereas he was not actually canonized until 1323. There is a wide range of different connections between the various characters, although they are all portrayed here as part of a vast propaganda programme, aimed at spreading the ideological message of the Dominicans. Just one example. Preaching, the most important way of enacting the "imitatio Christi," is the primary activity of all the monks portrayed; scrolls, parchments, books (half hidden, half open, fully open like the text Thomas Aquinas is holding, very small ones like the one of the Child) are a subtle reference to the evangelizing mission of this Order. In all, there are 27 books in this polyptych.

As far as the iconographical composition of the painting is concerned, Joanna Cannon's observation is very interesting: "A non-narrative programme which is original but not unorthodox, clear but not simple." Simone's absolute mastery of volumes and shapes, obtained thanks both to

50. *Polyptych. Detail of Saints Peter Martyr and Catherine in the middle level, and Saints Agnes, Ambrose, Ursula and Lawrence in the lower level*
Pisa, National Museum

Duccio's chiaroscuro technique and to his own recent experience in Assisi, is here blended with a very fluent use of vertical lines, of subtle and elegant modelling. The Gothic mood that Simone is here interpreting in terms of light, with a wide range of bright colours, creates a new relationship between image and space, between each individual measurement and the proportions of the whole composition. Some scholars believe that both the St Dominic and the Peter Martyr are to 49, be attributed to assistants. However, the problem of autography and attributing the various sections to the master or to his collaborators does not become a serious one until the following period, the years from 1320 to 1324, with the paintings produced by Simone's workshop in Orvieto.

The Orvieto Years

The new concept of a painter's workshop in the Middle Ages, with such a close collaboration between the master and his assistants, so close that they frequently exchange paintbrushes and even signatures, does not help us in our examination of the group of panel paintings dating from the early 1320s. Without going into the extremely difficult question of the identification of the various different hands, at least in many cases the presence of collaborators is unmistakable.

51 The *Orvieto Polyptych* is one such case. Even though we cannot be entirely certain of the year in which it was painted (despite the suggestion that there is a missing letter in the inscription "MCCCXX"), the style of the work is very much under the influence of the art of Giotto and the overall mood is one of great solemnity. The frontal composition and the use of certain stylistic elements (such as a fairly rigid volumetric construc-

48 tion) that the *Pisa Polyptych* appeared to have surpassed, suggest that only the figure of the Madonna is actually by Martini. Originally consisting of seven elements (and while St Peter, Mary Magdalene and St Dominic are all shown in exactly the same pose, St Paul is facing towards the right), this polyptych is now in the Cathedral Museum, although it was painted originally for the church of San Domenico. The painting was commissioned by the Bishop of Sovana, Trasmundo Monaldeschi, the former prior of the Dominican monastery, who paid a hundred gold florins for this altarpiece; he is portrayed in the panel together with Mary Magdalene.

52 Although recently some scholars have expressed their disagreement, in the past the *Polyptych* in the Isabella Stewart Gardner Museum, Boston, was always considered contemporary to the *Orvieto Polyptych*, or at the most dating from just a short while later. Originally in the church of Santa Maria dei Servi in Orvieto, the altarpiece consists of five panels: in the middle, the Madon-

na and Child; on either side, from left to right, Saints Paul, Lucy, Catherine of Alexandria and John the Baptist, all within a trefoiled ogival frame. In the cusps, the musician angels and the symbols of the Passion (the column and the whip of the Flagellation, the cross, the crown of thorns, the spear and the sponge) as well as the figure of Christ showing his wounds, suggest the iconography of the Last Judgment. Stylistically this polyptych is closer to the *Pisa Polyptych* than it is to 48 the one painted for the Dominicans in Orvieto, especially in details such as the slender figures, the long and graceful hands, more fluent and lighter volumes. In recent years it has become almost unanimously recognized as being by Simone, except for the St Paul, about whom there is still a fair amount of doubt.

There is another group of works that are dated by scholars at the early 1320s. From the stylistic point of view they are very close to the production of Simone and his assistants in the Orvieto workshop. The *Madonna and Child with Angels and* 54 *the Saviour* in the Orvieto Cathedral Museum (it is the central piece of a polyptych that also included the panel showing a martyred saint, now in the Ottawa National Gallery, and perhaps also the two panels of St Lucy and Catherine of Alexan- 55, dria, now in Harvard University's Berenson Collection in Settignano, near Florence) and the two Madonnas in the Siena Pinacoteca, one from Castiglione d'Orcia and the other from Lucignano 57 d'Arbia, are clearly related and must date from 58 more or less the same period. But we have no dates, no signatures and no documents containing any information at all regarding the dating of these works: stylistic analysis is the only element that critics have been able to use. This justifies the widely varying opinions that have been expressed on the subject: some scholars believe that they are totally autograph, while others think that Simone is responsible only for the drawings or for certain

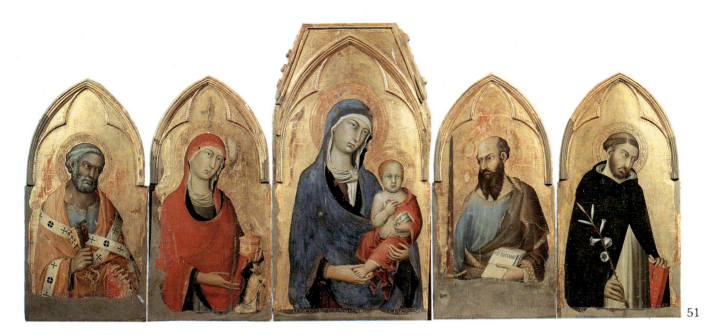

51. *Polyptych*
Orvieto, Cathedral Museum

52. *Polyptych*
Boston, Isabella Stewart Gardner Museum

51 sections of the painting, while others still consider them entirely the work of the workshop assistants. Nonetheless, there are many analogies between the various paintings, such as for example, the features of the Madonna in the *San Domenico Polyptych*, with her gentle and slightly dreaming eyes, repeated almost exactly in the Madonna in 54 the *Orvieto Polyptych*; or the lively pose of the

Child in the panel from Castiglione d'Orcia which 57 is exactly the same as that of the Child in the Boston painting. 52

A great deal has been written about the iconography of the *Madonna* from *Lucignano d'Arbia*, 58 very unusual in Sienese painting. Mary is shown looking to the right, instead of to the left, and she holds a Child who is not yet a "puer" (as was the

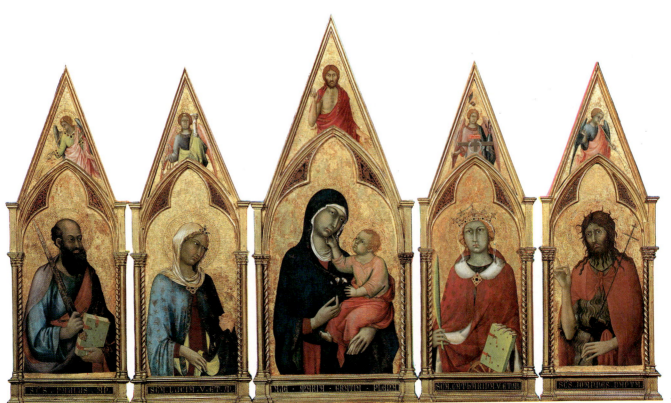

53

case in all the earlier paintings) but still an "infans" in swaddling clothes. The reason that led Martini to choose this iconography has yet to be explained, and it may have been a specific request from the client; but scholars do agree on the attribution of the panel to Simone.

59 The *Crucifix* from the church of the Misericordia in San Casciano Val di Pesa, first discovered and attributed to Martini in the early years of the 20th century, is undoubtedly contemporary to the paintings described above. Although there is no

53. *Polyptych*
Detail of the Madonna and Child
137 x 102 cm
Boston, Isabella Stewart Gardner Museum

54. *Madonna and Child with Angles and the*
Saviour
165 x 57 cm
Orvieto, Cathedral Museum

55. *St Catherine*
54 x 41 cm
Florence, Berenson Collection

56. *St Lucy*
51 x 40 cm
Florence, Berenson Collection

54

55

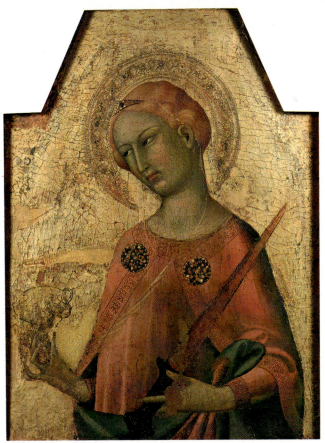
56

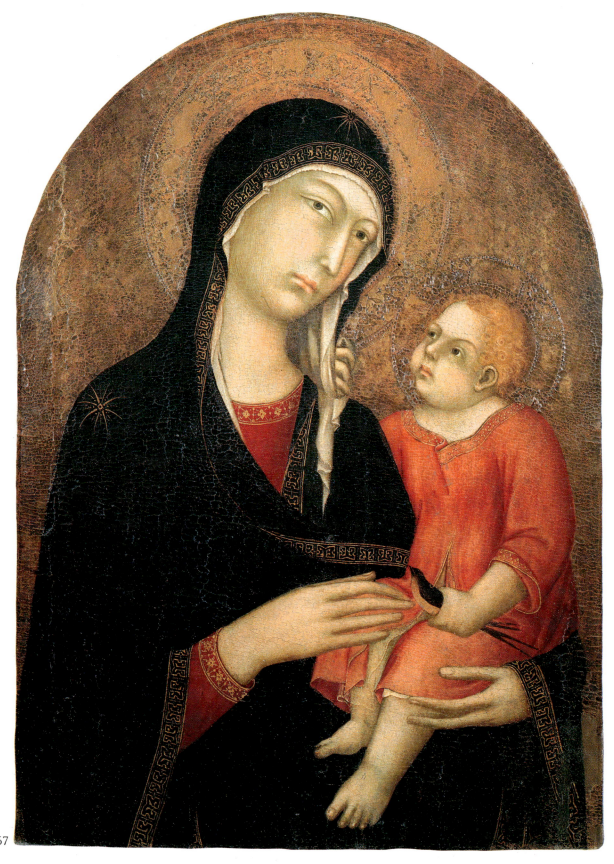

57

57. *Madonna and Child (from Castiglione d'Orcia)*
Siena, Pinacoteca

58. *Madonna and Child (from Lucignano d'Arbia)*
88 x 51 cm
Siena, Pinacoteca

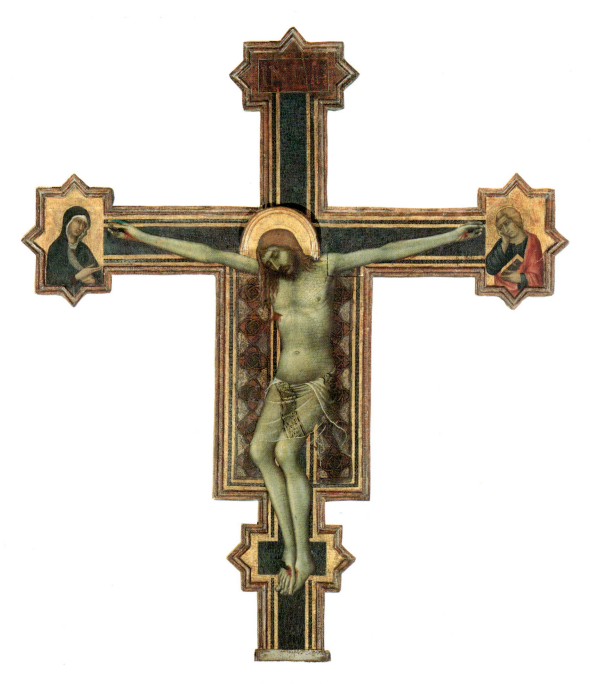

59. Crucifix
164 x 147
San Casciano (Florence), Church of the
Misericordia

documentation at all regarding it, some scholars have suggested that it is the Crucifix that Simone painted in 1321 for the Chapel of the Nine in Siena. This theory is not very convincing, however, because if we examine our sources carefully it becomes clear that what Simone painted in that chapel was a fresco and not a panel — a fresco which was then destroyed by a fire. The closest analogies that this Crucifix presents are with the Pisa and Boston polyptychs.

Simone's Second Sienese Period

After having spent several years in Assisi, Pisa and Orvieto, only occasionally returning to Siena for very brief periods during which he worked in the Palazzo Pubblico (on one occasion to retouch the *Maestà*, on another to paint some works that are no longer extant), Simone actually returned to Siena on a stable basis. This appears to have been a rather calm period of his life and it was at this time that he married Giovanna Memmi: perhaps feeling tired after his travels, working for so many different patrons in different places, Simone decided to settle in his home town. It was sometime around 1325 and Martini was a well established painter, at the height of his artistic maturity. His experiences working for the House of Anjou and the Franciscans, in international environments where political interests frequently took the place of religious spirit and where art became an effective means of visualizing and promoting temporal power, had made Martini much more a man of the world: he had set off from Siena as a talented but simple Sienese painter, and he returned as a famous artist, self-confident and experienced. Back in Siena, Simone worked for the Government of the Nine adding more and more splendid works to the Palazzo Pubblico, year after year; most of these paintings have not survived and we only know about them from the payments recorded in the Biccherna ledgers. It was during this second Sienese period that Simone painted some of his most famous paintings, such as the *Blessed Agostino Novello* 60 *Altarpiece*, the celebrated fresco of *Guidoriccio* 64 *da Fogliano* and the *Annunciation* now in the 69 Uffizi, the only one that is actually signed and dated.

The Blessed Agostino Novello Altarpiece

The story of the Blessed Agostino Novello is an example of that form of popular religious spirit that grew up in the towns of Tuscany in the late 13th century and the early 14th. The Church's official saints were considered too remote by the people and spiritually so different from the reality of the times that they could not entirely satisfy the religious fervour that developed in those years. The people felt that they needed more tangible examples of holiness, more closely connected to daily reality, rather like St Francis of Assisi had been. As a result, some of the better known citizens, whose charitable and religious deeds were known to all (and in may cases miracles were attributed to them), were canonized as saints or blessed.

Agostino Novello was one of these figures. After a brilliant career both as a layman and as a cleric (he studied law at the University of Bologna and became personal councillor to King Manfred, the son of Ludwig II; when he joined the Augustinian Order he became Prior General), Agostino Novello then renounced community life and retired to the hermitage of San Leonardo al Lago, near Siena. After his death in 1309, the worship of this saintly man spread so fast that the monks of his Order tried to have him nominated patron saint of the city: through the veneration of a member of their Order, the Augustinians were sure to gain prestige and power. But Agostino was not made patron saint of Siena, despite the fact that he must indeed have been the object of great veneration to judge by the impressive funerary monument that was built for him.

Thanks to Max Seidel's research we are now able to reconstruct the history of the altarpiece that portrays the Blessed Agostino Novello and 60 four of his miracles. Now in the Pinacoteca in Sie-

59

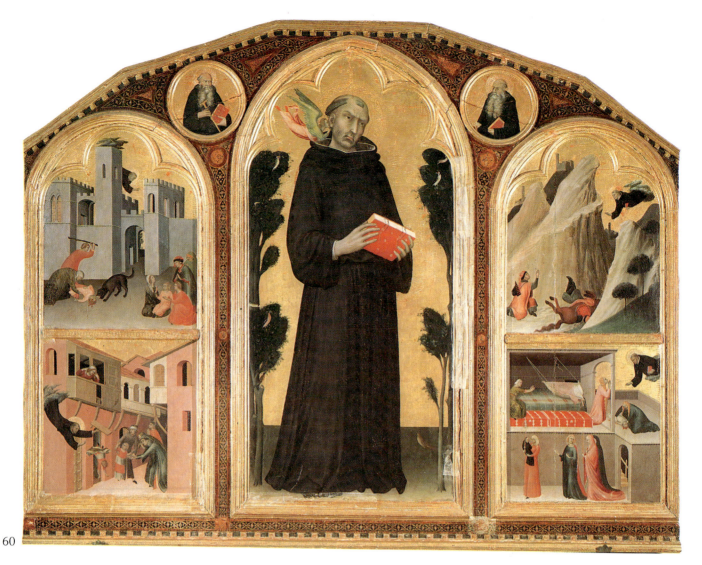

na, the painting hung originally in the church of Sant'Agostino, probably above the wooden sarcophagus in which the Blessed Agostino was buried; together with the altar consecrated to him, these two elements formed a burial monument rather like the one constructed for St Ranieri in Pisa Cathedral by Tino di Camaino about twenty years earlier. The dating of this altarpiece can only be approximated. We can only suppose that it was already finished and in place on the occasion of the celebrations in honour of the Blessed Agostino held in 1324 and for which the Commune of Siena allotted a huge sum of money.

The iconography, at least for modern observers like us, is clear but not that simple to understand. The central area, framed by a multifoiled ogival arch, encloses the figure of Agostino, who is given a saint's halo even though he had not been canonized. The wooded landscape, the old hermits in the medallions and the scene of the conversation with the angel (an episode that does not appear in any of the biographies) are all references to the hermit's life he led at San Leonardo al Lago. On the other hand, the face of Agostino,

portrayed still as a young man, the red book he carries (perhaps the *Constitutiones* of the Order, which he had drawn up himself), as well as the fact that the miracles are all taking place in a very realistically described Siena, all suggest Agostino's political commitments and the pastoral duties he performed in the city. As Seidel correctly suggests, "the status perfectissimus, which Agostino reached in imitation of Augustine of Hippo, consisted in a synthesis between active life and contemplative life." The miraculous powers of the Blessed Agostino are fully displayed in the scenes depicted at the sides of the central area; they are framed by trefoiled round arches and illustrate four miracles. The idea of Agostino's holiness, stressed by the sudden appearances of winged angels, was intended to capture the mediaeval public's religious sensitivity: the victims of the terrible accidents are for the most part children. The scenes are organized according to the composition of ex-votos, each one being divided into two sections: the accident and the miracle, followed by a thanksgiving prayer. The architectural settings of the scenes depict an overall view of Siena

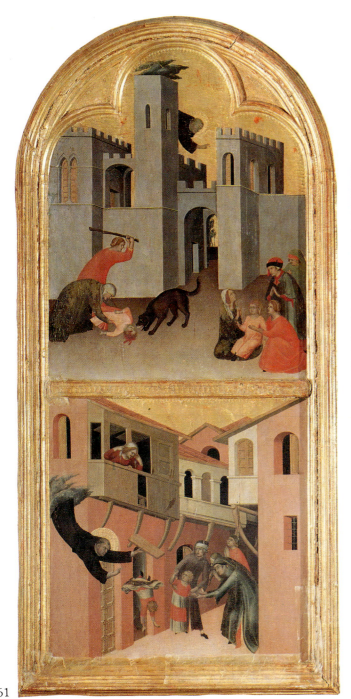

61

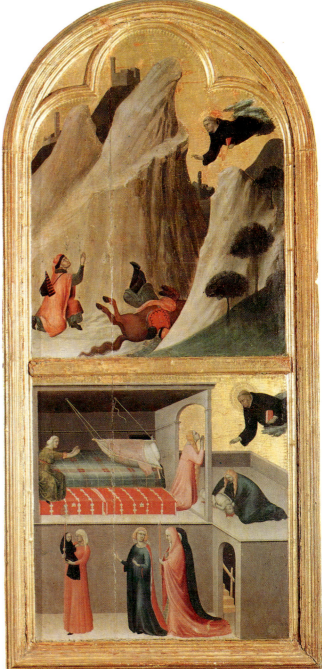

62

60. *Blessed Agostino Novello Altarpiece*
198 x 257 cm
Siena, Pinacoteca

61. *Blessed Agostino Novello Altarpiece*
Detail of two scenes: a Child Attacked by a Wolf
and a Child Falling from a Balcony
Siena, Pinacoteca

62. *Blessed Agostino Novello Altarpiece*
Detail of two scenes: a Knight Falling down a
Ravine and a Child Falling out of his Cradle
Siena, Pinacoteca

61 (in the *Child Attacked by a Wolf*), a view of the
narrow streets of the city (in the *Child Falling from
a Balcony*) and even an interior scene (in the
62 *Child Falling out of his Cradle*, also known as the
Paganelli Miracle); and in fact one could say that
the city of Siena is indeed the co-protagonist of
this painting. The buildings of the city centre are
counterbalanced by the rural landscape in the
62 scene of the *Knight Falling down a Ravine*, probab-
ly a depiction of the countryside immediately out-
side Siena, with the towers of faraway castles
standing out amidst the bare hills.

The Altomonte Panel

In 1326 Filippo di Sanguineto, Count of Al-
tomonte and an Anjou Court dignitary, came to
Siena as part of the retinue of Charles, Duke of
Calabria, the heir to the throne of Naples. When
the Duke later left Tuscany, Count Filippo stayed
behind as a royal deputy; his task was to keep un-
der control the animosity of the Ghibelline forces,
led by the very bellicose Castruccio Castracani. It
seems quite likely that during his stay in Siena the
Lord of Altomonte met the artist who had given
such a masterly portrayal of the Anjou of Naples
and of Hungary on the walls of the Lower Church
45 in Assisi and in the *Naples Altarpiece* commis-
sioned by King Robert. So he presumably seized
this opportunity to commission a small painting
himself, probably a diptych; the little panel show-
63 ing *St Ladislaus, King of Hugary*, now in the
Museo della Consolazione in Altomonte, was
probably part of that diptych. The choice of St
Ladislaus is perfectly justified by the ties of loyalty
that bound Filippo di Sanguineto to the Hungari-
an branch of the House of Anjou, a loyalty which
will later play an important role in the dynastic
conflicts. Although the spatial construction of this
small panel is very close to that of the *Blessed
60 Agostino Novello Altarpiece*, the volumes are
deeper and there is a wider range of colour. The
gold background, with its elaborate and delicate
etching, surrounds the saint; standing in a rigidly
frontal position, armed with his battle-axe, he re-
minds us of his valour and his heroic actions in
war.

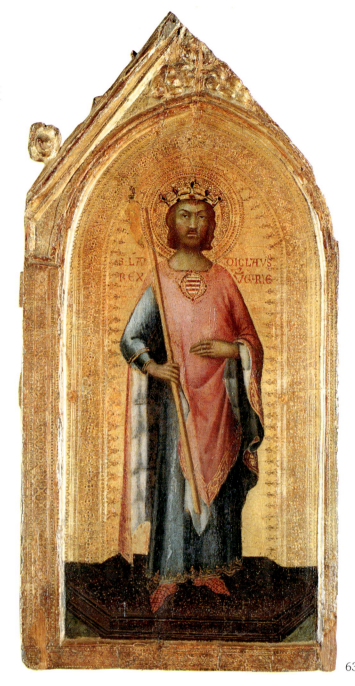

63

63. *St Ladislaus*
45.5 x 21.5 cm
Altomonte (Cosenza), Museo della Consolazione

64. *The wall with the Guidoriccio da Fogliano*
Siena, Palazzo Pubblico

62

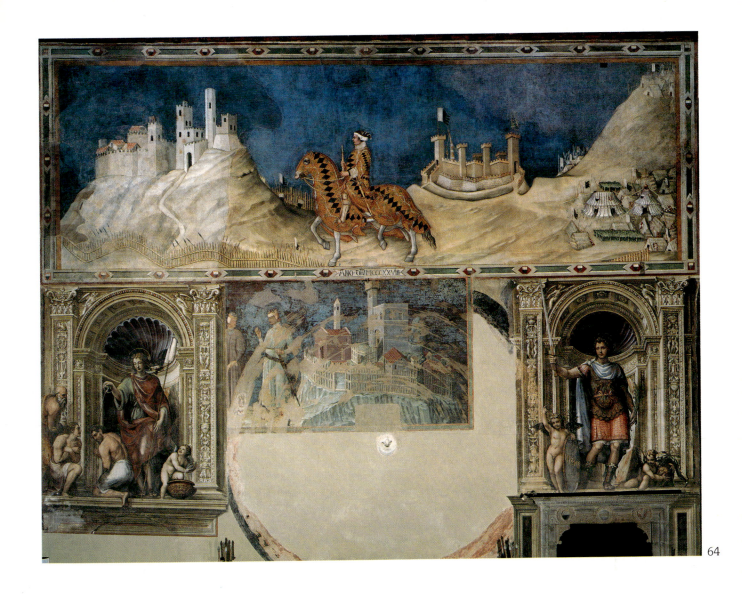

64

Guidoriccio

64 About ten years ago, the famous fresco of *Guidoriccio da Fogliano*, which had always been considered the greatest example of Martini's artistic excellence, was re-attributed by Gordon Moran to a much later artist. The controversy that followed this re-attribution, further stimulated by the discovery of a fresco below the Guidoriccio (a very beautiful one, and certainly much older as we can see from the overlapping of the intonaco), turned into an animated diatribe that has not yet been placated. It wasn't just a question of pronouncing oneself in favour or against the attribution to Martini of the Guidoriccio, it also became important to interpret the iconography of the newly discovered fresco and to identify the extremely talented artist who had painted it. The following are the suggestions made by some of the most eminent art historians: Seidel and Bellosi believe that it shows the Capture of Giuncarico

and is the work of Duccio; Frugoni and Redon think that it is by Martini and depicts Guidoriccio Conquering Arcidosso; Brandi attributes it to Pietro Lorenzetti and Carli to Memmo di Filippuccio. This incredible difference of opinions is justified by the fact that most scholars have based their theories entirely on stylistic analysis. The observer may be surprised by this variety of attributions, especially since the artists mentioned are all so different. But for the public in general, informed by the unusual amount of space the press devoted to the matter, and also for those who take a professional interest, the main problem was how to form one's own opinion. How disorienting… when learned art historians contradict one another so drastically? It is difficult to find one's way through this maze of facts that have been used to support first one theory and then another — accurate biographies of Guidoriccio have alter-

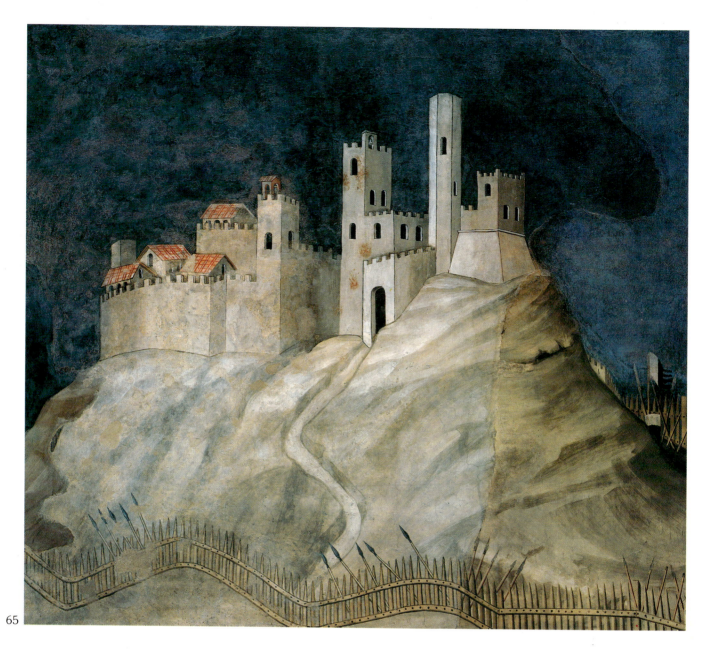

65

nated with research on Siena's expansionistic policy in the 14th century, or with essays on the restoration procedures that the fresco has undergone and studies of recent techniques, or detailed studies in topography or heraldry, or on the costumes of Trecento condottieri.

Those who don't believe that the Guidoriccio fresco is by Simone suggest that it may well be the overall repainting of an earlier fresco. A recent cleaning has shown that the whole of the lefthand section, including the Castle of Montemassi, was repainted in the 15th or 16th century. An ultrasound echogram has also shown that in the righthand section, where the camp appears in the foreground, there are four overlapping layers of intonaco on the wall. In other words, the silent landscape of the Guidoriccio fresco probably conceals something much older. In order to clarify matters, it is necessary not only to remove the

65. *Guidoriccio da Fogliano*
Detail of the village
Siena, Palazzo Pubblico

66. *Guidoriccio da Fogliano*
Detail of the knight
Siena, Palazzo Pubblico

large stucco patch that extends vertically along the righthand edge (by doing so we would be able to determine precisely the order in which the intonaco was applied, thereby establishing the chronological relationship between the *Guidoriccio* and the *Battle of Valdichiana* that Lippo Vanni painted in 1363), but also a small patch of sky to verify whether this pale blue-grey expanse conceals some precious treasure.

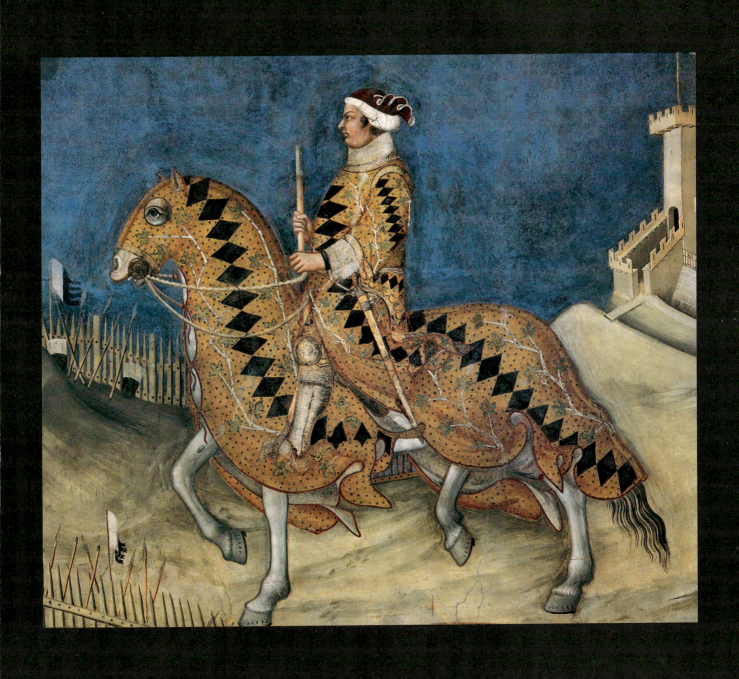

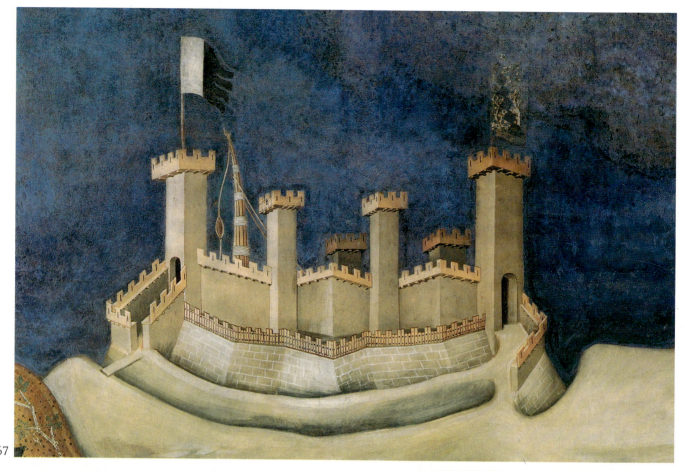

67

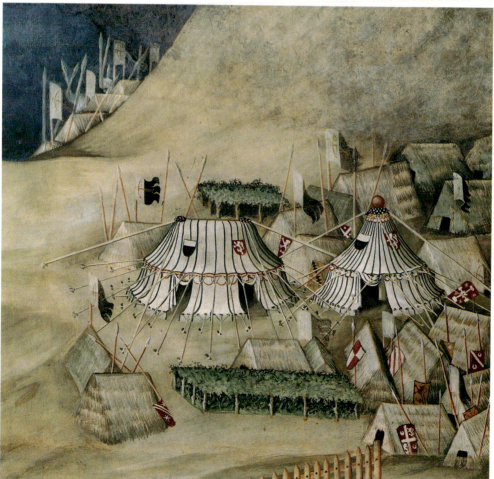

68

67. Guidoriccio da
Fogliano
Detail of the castle
Siena, Palazzo Pubblico

68. Guidoriccio da
Fogliano
Detail of the camp
Siena, Palazzo Pubblico

69. Annunciation
265 x 305 cm
Florence, Uffizi

70. Annunciation
Detail of the angel
Florence, Uffizi

71. Annunciation
Detail of the Madonna
Florence, Uffizi

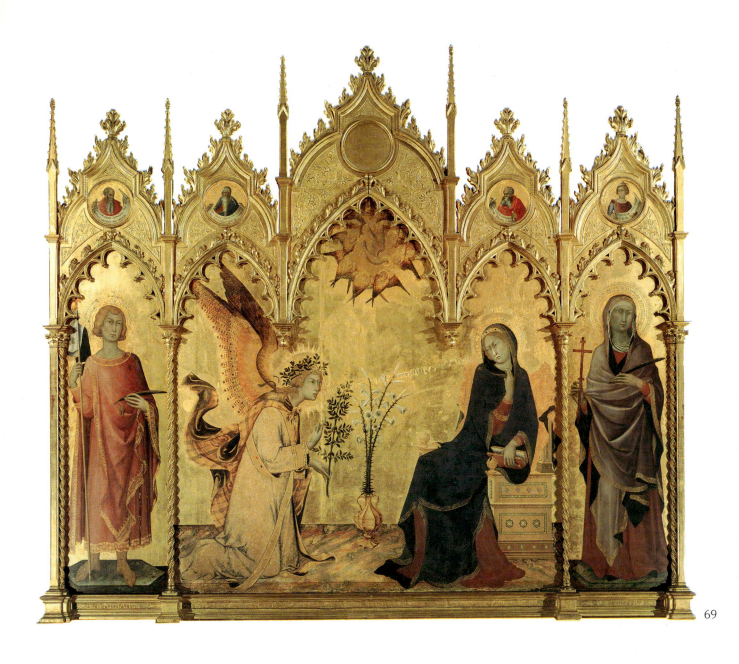

The Annunciation

In 1333, with the assistance of Lippo Memmi, Martini painted for the Chapel of Sant'Ansano in Siena Cathedral an *Annunciation* that is now in the Uffizi in Florence. The double signature visible inside the 19th-century frame, "Symon Martini et Lippus Memmi de Senis me pinxerunt anno domini MCCCXXXIII," has given rise to the problem of distinguishing between the parts that are by Simone and those that are by Memmi. The following are the theories expressed most recently by art historians: some suggest that Lippo is responsible for almost the entire painting; others attribute to Martini the St Ansano, the Archangel and Mary, and to Lippo only the figure of St Giulitta; others still feel that the altarpiece is a perfect example of the artistic collaboration of the

two masters, the best product of their joint workshop.

The iconography of the painting is extremely clear. At the top, within the medallions, there are four prophets, identifiable thanks to the inscriptions on their scrolls: from left to right, Jeremiah, Ezechiel, Isaiah and Daniel. The roundel in the cusp (which is now empty) probably contained an image of God the Father, since the dove of the Holy Ghost, immediately below, was usually portrayed together with an image of the Almighty. Gabriel's greeting, "Ave Gratia Plena Dominus Tecum," is inscribed on the gold background, and there are other words inscribed along the edges and on the sash of the Archangel's robe, but they are not easy to read. This splendidly linear com-

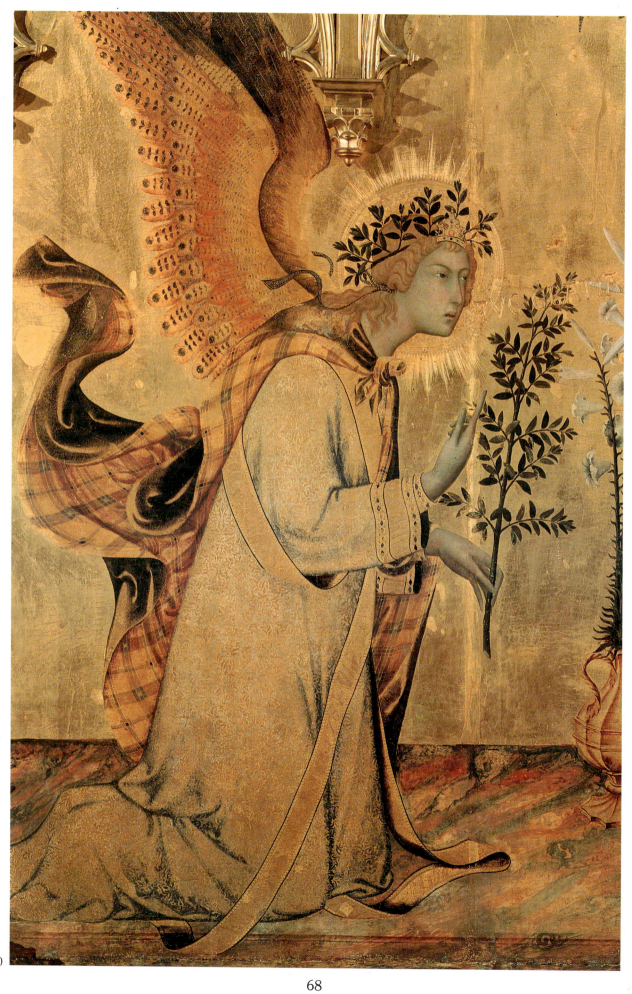

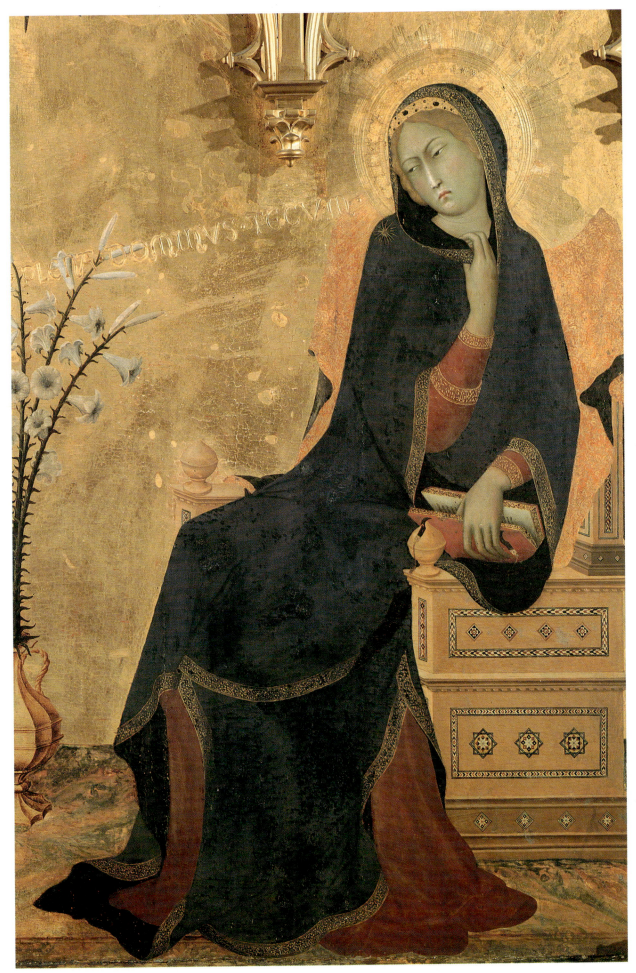

position, in which the two-dimensional feeling does not prevent the volumes from being well-defined and the edges sharp, is full of acute and realistic observations: the veined marble on the floor, the half-opened book, the vase in the middle with the lilies, the inlaid decorations on the throne.

Simone Martini in Avignon

Thanks to the evidence provided by two sonnets by Petrarch, written on 4 November 1336, "Per mirar Policleto a prova fiso" and "Quando giunse a Simon l'alto concetto," we know that Simone arrived in Avignon, accompanied by his family and several collaborators, around the beginning of 1336. He had been called to Avignon by one of the Italian Cardinals, probably Jacopo Stefaneschi, who had also moved to the new papal seat. It was for Cardinal Stefaneschi that Simone frescoed the church of Notre-Dame-des-Doms in Avignon. The portal frescoes, the 72, 73 *Saviour Blessing* and the *Madonna of Humility*, the synopias of which are now in the Palace of the Popes, although in very bad condition, are interesting and reveal a very high quality.

Also thanks to Petrarch's sonnets we know that the poet and the painter became very good friends. Simone must undoubtedly have been influenced by the proto-Humanist cultural world of Petrarch, and we can see clearly how the manu-74 script illumination of Petrarch's Virgil in the Biblioteca Ambrosiana in Milan, with its classical and naturalistic overtones (sophisticated gestures, white cloth drapery, the delicate figures of the shepherd and the peasant), anticipates the typical style of early 15th-century French manuscript illumination.

75-78 The altarpiece known as *Passion Polyptych*, with panels now in a number of European museums, is signed "Pinxit Symon "on the two 76, 77 panels of the *Crucifixion* and the *Deposition*. It presents several problems, both in terms of stylistic analysis and dating. Some scholars, stressing the fact that it is so different stylistically from all the other works of Simone's Avignon period (nervous lines and expressions), think that it may have been painted earlier and then transported to France; others believe that it may be a late work, commissioned by Napoleone Orsini, who died in the Curia in Avignon in 1342. Orsini's coat-of-arms appears in the background of the *Road to* 75 *Calvary*. The polyptych was probably transferred to the charterhouse of Champmol, near Dijon, in the late 14th century.

The last known work of Simone's career as a painter is the Liverpool *Holy Family*, signed and 79 dated "Symon de Senis me pinxit sub a.d. MCCCXLII." The iconographical subject, so rare, and actually used here for the first time, comes from the Gospel according to Luke, as we can see from Mary's book, "Fili, quid fecisti nobis sic?" (Son, why hast thou thus dealt with us?, Luke, 2:48). The scene shows Joseph leading Jesus back to his mother, after the three days he had spent with the doctors in the temple. The characters are bound by a feeling of intimacy and familiarity; they are portrayed in natural and spontaneous poses, with Mary reproaching her son, and reveal a deep and totally human family love.

Whatever Simone may have painted during the last two years of his life, nothing has survived.

72. *The Saviour Imparting His Blessing*
Avignon, Notre-Dame-des-Doms

73. *Madonna of Humility*
Avignon, Notre-Dame-des-Doms

71

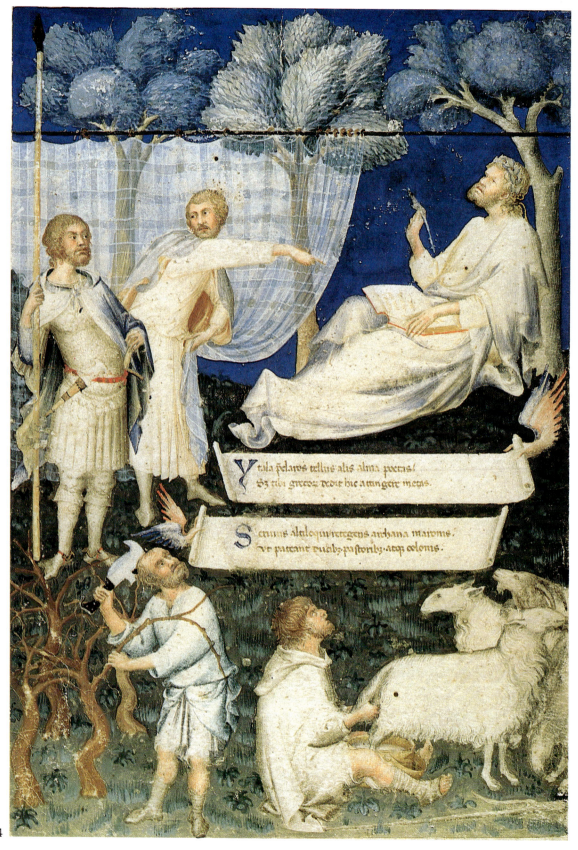

74

74. *Title-page of Petrach's Virgil*
29.5 x 20 cm
Milan, Biblioteca Ambrosiana

75. *Orsini Polyptych*
Panel of the Road to Calvary
25 x 16 cm
Paris, Louvre

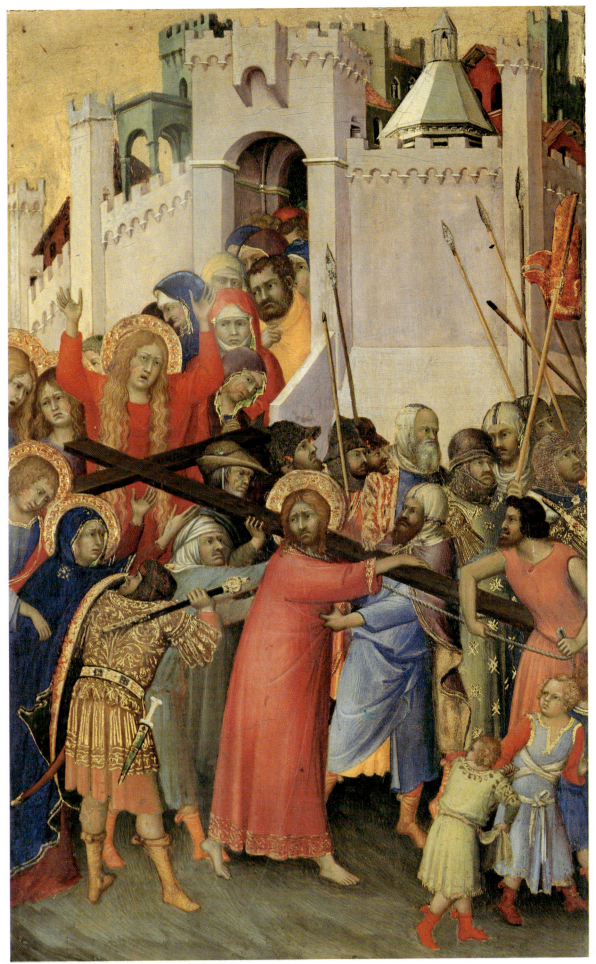

75

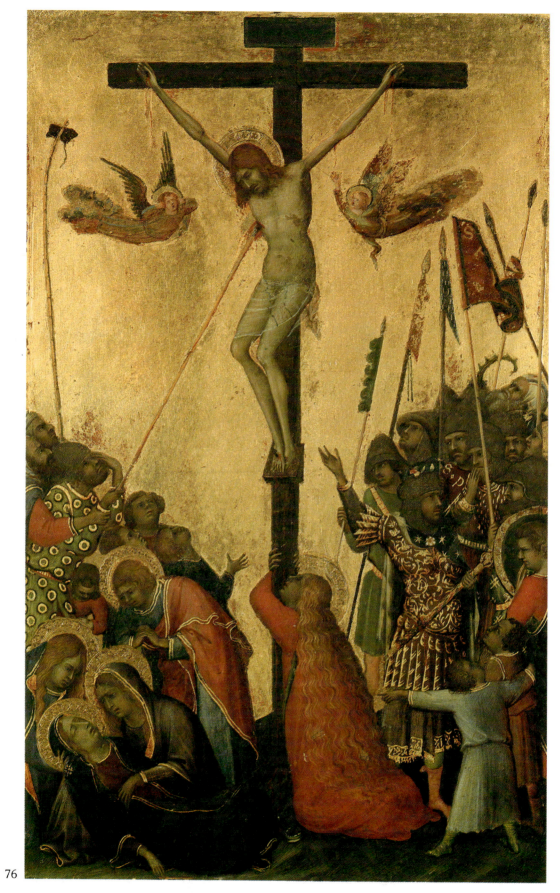

76

76. Orsini Polyptych
Panel of the Crucifixion
24.5 x 15.5 cm
Antwerp, Musée Royal des Beaux Arts

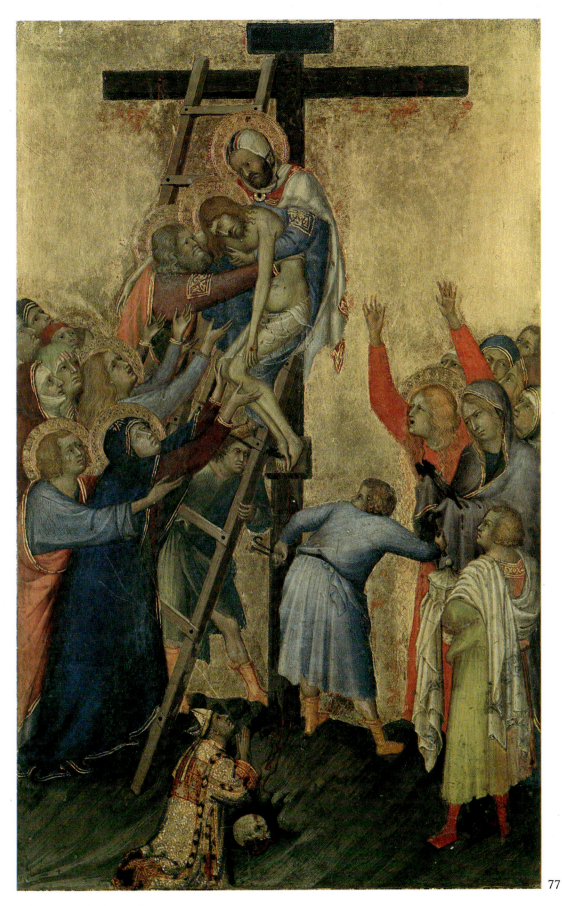

77. *Orsini Polyptych*
Panel of the Deposition
24.5 x 15.5 cm
Antwerp, Musée Royal des Beaux Arts

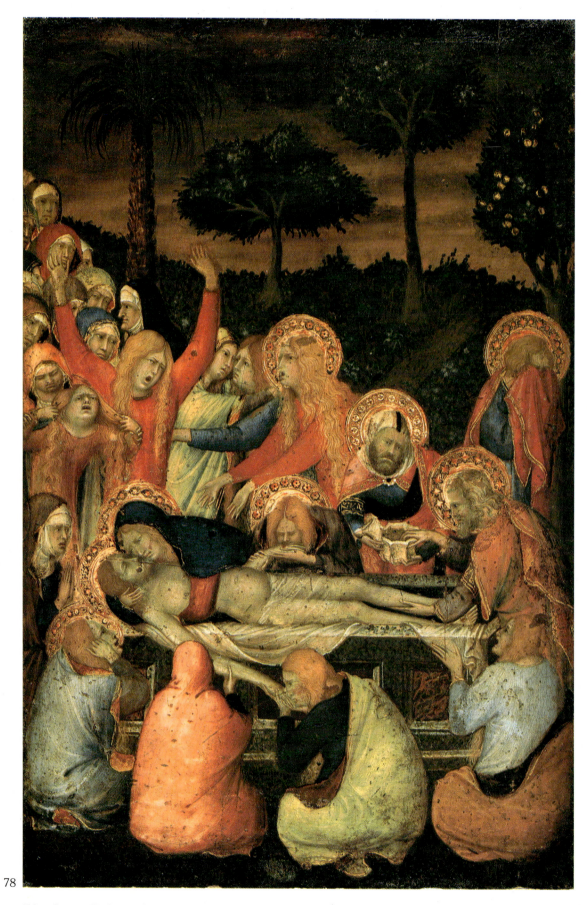

78

78. *Orsini Polyptych*
Panel of the Entombment
22 x 15 cm
Berlin, Gemäldegalerie Dahlem

79. *Holy Family*
50 x 35 cm
Liverpool, Walker Art Gallery

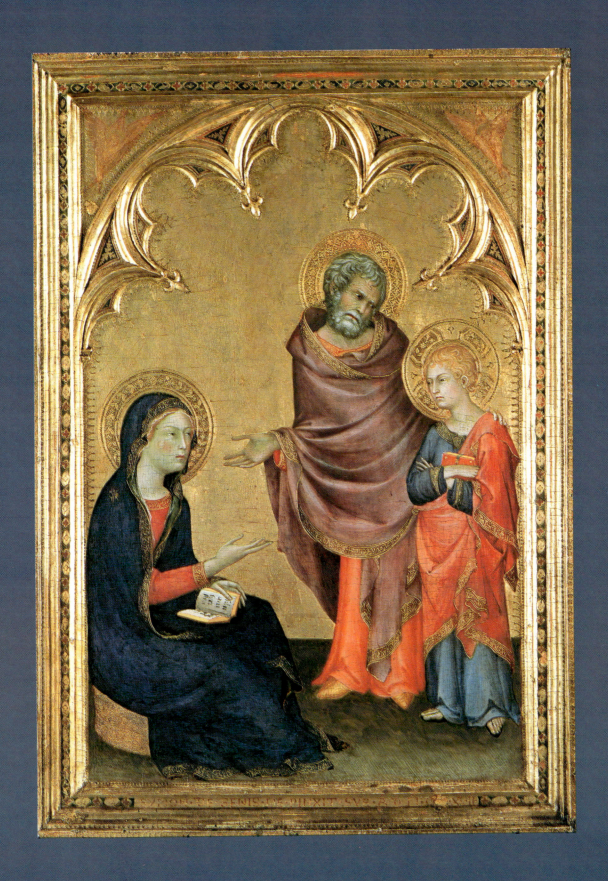

Chronology

1284 This is probably the year of Simone's birth.

1315 Simone paints the *Maestà* in the Palazzo Pubblico in Siena: the fresco is signed and dated.

1317 Simone receives a gift of fifty ounces of gold from King Robert of Anjou. The panel of *St Louis of Toulouse* (signed) probably dates from this year.

1319 The *polyptych* for the church of *Santa Caterina in Pisa*, signed.

1320 The inscription "A.D.MCCCXX," considered incomplete, appears on the frame of the *polyptych* in the Cathedral Museum in *Orvieto*. This same date (although it is considered apocryphal) appears on the frame of the *St John the Evangelist* in the Barber Institute in Birmingham.

1321 Together with his collaborators, Simone is paid for restoring the *Maestà* (twenty-seven lire) and for a *Crucifix* to be placed above the altar in the Chapel of the Nine in the Palazzo Pubblico in Siena (twenty florins).

1322 The Biccherna ledgers record payments to Simone for some unspecified paintings in the Palazzo Pubblico.

1323 Also in the Palazzo Pubblico Martini paints a further group of works and a St Christopher with the coat-of-arms of Podestà Mulazzo de' Mulazzi from Macerata (all destroyed).

1324 In January-February Simone buys a house from Memmo di Filippuccio and gives Giovanna, his wife-to-be, the sum of two hundred and twenty gold florins.

1326 He paints a panel for the Palazzo del Capitano del Popolo (now lost) and appears as witness in a land rental contract at Montecchio, near Siena.

1327 He is paid ten gold florins for two painted banners that the Commune of Siena presents to Charles, Duke of Calabria.

1329 He paints two angels for the altar of the Nine in the Palazzo Pubblico (now lost) and is paid for a service he rendered the Commune, involving a two week stay in Ansedonia.

1330 He paints the portrayal of the rebel Marco Regoli in the Sala del Concistoro in the Palazzo Pubblico (lost) and is paid for the fresco of the Capture of Montemassi.

1331 In September he goes to see the castles of Arcidosso and Castel del Piano which he will paint three months later on the walls of the Sala del Mappamondo.

1332 He is paid three gold florins for the pedestal of a Cross and for other unspecified works for the Chapel of the Nine.

1333 This is the date that appears, together with the signatures of Simone and Lippo Memmi, on the *Annunciation* painted for Siena Cathedral (now in the Uffizi in Florence).

1336 Two sonnets by Petrarch, dated 4 November, attest that Simone was already in Avignon.

1340 Simone and Donato Martini are nominated by the Papal Curia of Avignon as the official representatives of a Sienese church.

1342 Simone signs and dates the *Holy Family* now in the Walker Art Gallery in Liverpool.

1344 Simone's funeral is celebrated in the church of San Domenico in Siena.

Basic Bibliography

E. CARLI, *Simone Martini*, Milan 1959

E. CASTELNUOVO, *Un pittore italiano alla corte di Avignone. Matteo Giovannetti e la pittura in Provenza nel sec. XIV*, Turin 1962

J. ROWLANDS, *The date of Simone Martini's arrival in Avignon*, in "The Burlington Magazine", CVII, 1965, pp. 25-26

C. DE BENEDICTIS, *Sull'attività orvietana di Simone Martini e del suo seguito*, in "Antichità viva", VII, 1968, pp. 3-9

F. BOLOGNA, *I pittori alla corte angioina di Napoli, 1266-1314*, Rome 1969

G. CONTINI-M. C. GOZZOLI, *L'opera completa di Simone Martini*, Milan 1970

G. MORAN, *An Investigation Regarding the Equestrian Portrait of Guidoriccio da Fogliano in the Siena Palazzo Pubblico*, in "Paragone", 333, 1977, pp. 273-274

S. PADOVANI, *Una tavola di Castiglione d'Orcia restaurata di recente*, in "Prospettiva", 17, 1979, pp. 82-88

M. SEIDEL, *Castrum pingatur in palatio I. Ricerche storiche e iconografiche sui castelli dipinti nel Palazzo Pubblico di Siena*, in "Prospettiva", 28, 1982, pp. 17-41

L. BELLOSI, *Castrum pingatur in palatio 2. Duccio e Simone Martini pittori di castelli senesi "a l'esemplo come erano"*, in "Prospettiva", 28, 1982, pp. 41-65

C. FRUGONI, *Una lontana città*, Turin 1983

G. CHELAZZI-DINI, *Un capolavoro giovanile di Simone Martini* in "Prospettiva", 33-36, 1983-84, pp. 29-32

G. RAGIONIERI, *Simone o non Simone*, Florence 1984

M. SEIDEL, *Conversatio angelorum in silvis. Eremiten-Bilder von Simone Martini und Pietro Lorenzetti* in "Städel-Jahrbuch", 10, 1985, pp. 77-142

Simone Martini e chompagni, catalogue of the exhibition, Siena 1985

Simone Martini, Atti del convegno, Siena 1988

Index of Illustrations